Collins · Learn to Draw

Caricatures

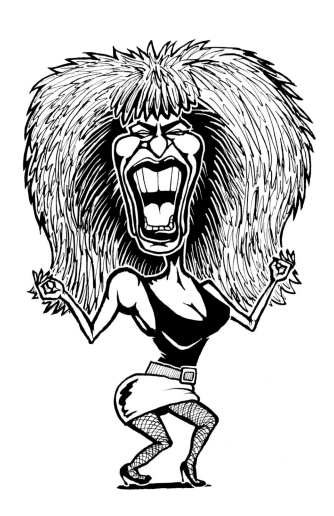

Alex Hughes

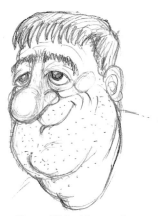

First published in 1999 by
HarperCollins Publishers

Reprinted in 2006 by
Collins, an imprint of
HarperCollins Publishers
77–85 Fulham Palace Road
Hammersmith, London w6 8jb

The Collins website address is: www.collins.co.uk
Collins is a registered trademark of HarperCollins Publishers Limited.

07 09 10 08
2 4 6 7 5 3

A catalogue record for this book is available from the British Library.

Produced by Kingfisher Design, London
Editor: Diana Vowles
Art Director: Pedro Prá-Lopez
Designer: Frances Prá-Lopez

Contributing artists:
Femi Adetunji (*pages 9, 12, 34 bottom right, 36 left, 52 top left, 57 bottom right*) Jonathon Cusick (*pages 29 bottom right, 37 bottom left, 56 bottom right, 57 top left, 58 top left and bottom right*) Gary Dillon (*pages 36 right, 56 top*) Andy Lawson (*pages 17 right, 34 bottom left*)
John Leer (*pages 6 left, 37 bottom right, 57 bottom left, 63*) Janet Nunn (*pages 37 top, 59 top left, 60 bottom left*)

Laughing Gravy Design: Caricature by Gary Dillon courtesy of Cargill plc (*page 59 bottom left*)
The caricature of Jeremy Paxman on page 54 first appeared in *The Big Issue*.
The caricature of Eric Cantona on page 55 first appeared in advertisements for *New Internationalist*.
The caricature of Gordon Brown on page 62 first appeared in *Red Pepper*.

Caricatures appearing on the following pages are:
Page 1: singer, Tina Turner
Page 2: the author, Alex Hughes
Page 3: rock star, The Artist Formerly Known As Prince
Back page: former American president, Richard Nixon

ISBN–13 978 0 00 721594 2
ISBN–10 0 00 721594 0

Colour reproduction by Colourscan, Singapore
Printed and bound by Printing Express Ltd, Hong Kong

CONTENTS

Introduction

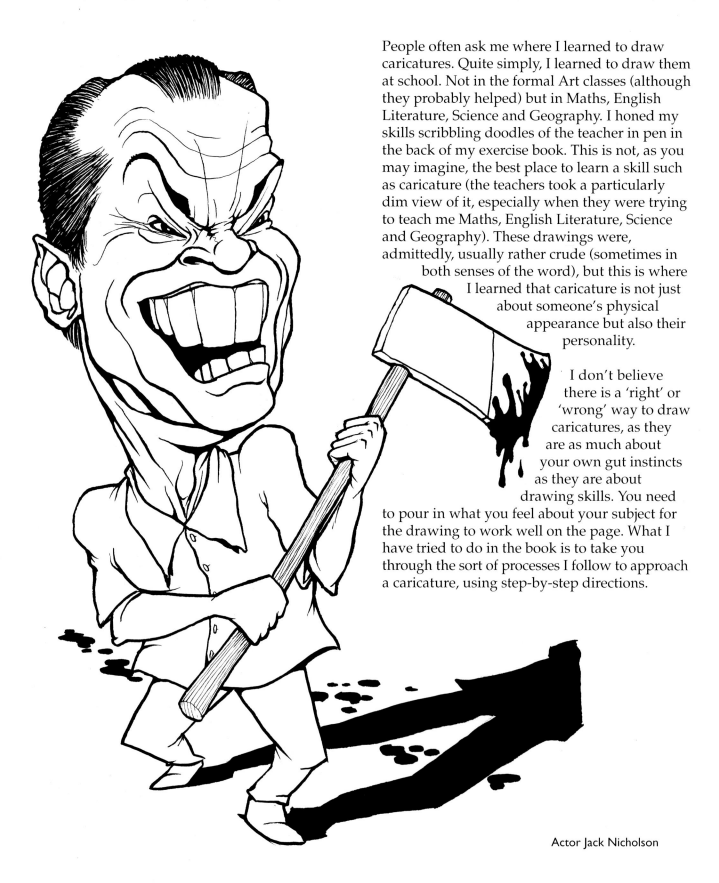

People often ask me where I learned to draw caricatures. Quite simply, I learned to draw them at school. Not in the formal Art classes (although they probably helped) but in Maths, English Literature, Science and Geography. I honed my skills scribbling doodles of the teacher in pen in the back of my exercise book. This is not, as you may imagine, the best place to learn a skill such as caricature (the teachers took a particularly dim view of it, especially when they were trying to teach me Maths, English Literature, Science and Geography). These drawings were, admittedly, usually rather crude (sometimes in both senses of the word), but this is where I learned that caricature is not just about someone's physical appearance but also their personality.

I don't believe there is a 'right' or 'wrong' way to draw caricatures, as they are as much about your own gut instincts as they are about drawing skills. You need to pour in what you feel about your subject for the drawing to work well on the page. What I have tried to do in the book is to take you through the sort of processes I follow to approach a caricature, using step-by-step directions.

Actor Jack Nicholson

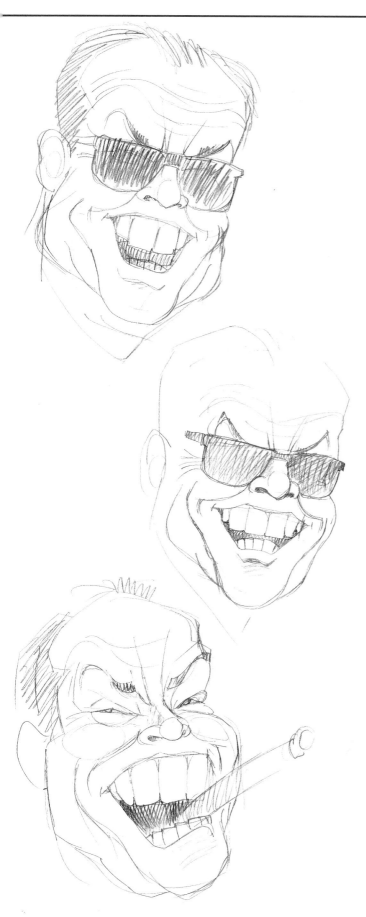

Having followed my approach, you may well develop your own methods that you find are more effective for the way you work.

Don't expect to become an ace caricaturist overnight. If there is a secret to caricature it must be 'practice' – but don't forget, caricatures are supposed to be fun. If you're not enjoying it, the caricature won't work. It's also advisable not to try out your caricaturing skills on your friends and family straight away unless you are extremely confident – or just very big. Some people just can't take a joke. Remember, if you're going to dish it out, you may have to take it as well. Caricature can make you friends, but it can also make you enemies.

Oh, and please don't get too good, or I'll be out of a job.

Business troubleshooter
Sir John Harvey-Jones

Tools and Equipment

First you should consider which media you wish to produce your finished caricature in – and what you choose will depend upon the sort of image you want to create.

Pencils

Pencils are the most versatile medium, useful for making either rough sketches or finished caricatures. Graphite (lead) pencils come in a wide range, from 9H, which draw a fine, light line, through to 9B, which are soft and produce thick black lines. In the middle of the scale are HB pencils. Harder pencils are ideal for light sketching and preparatory work before going over the drawing in ink or paint, while softer pencils can be used for subtle tones. Softer pencils are more susceptible to smudging, but you can use this to your advantage, blurring lines to create softer tones. Your finished artwork can then be preserved from further smudging by spraying it with fixative.

As well as traditional wooden pencils there are propelling and clutch pencils, which use a fine lead and don't need continual sharpening. Pencils are also available in colour, as are water-soluble pencils, which you draw with as usual, creating the impression of paint if you wish to by then applying brush and water.

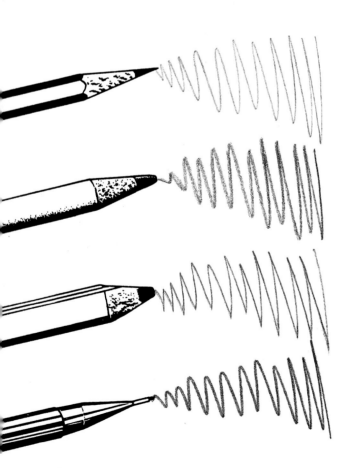

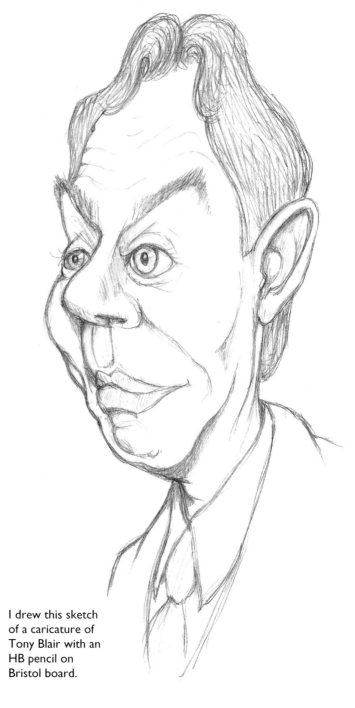

I drew this sketch of a caricature of Tony Blair with an HB pencil on Bristol board.

Pens

There are a variety of pens available, with which you can produce a large range of effects.

Dip pens have nibs in many styles from fine mapping nibs to calligraphy nibs. By applying pressure to the nib you can vary the line considerably. Dip pens can be used with any inks including coloured and waterproof inks, unlike fountain pens which can only use non-waterproof or writing inks that don't clog the nib. However, some of the latter do have the advantage that they can use cartridges.

Ballpoint pens are cheap and efficient and give an even line. They are useful for doodling and sketching, but don't offer much variety and are prone to smudging and leaving blobs of ink.

Technical pens yield a fine, constant line, are good for detailed work, and are available in a range of sizes. They clog easily and need to be cleaned regularly.

Felt-tip pens are useful for bold, quick sketches and are available in a range of sizes and tip shapes. Be warned that felt-tip pen has a tendency to fade if exposed to daylight for long periods.

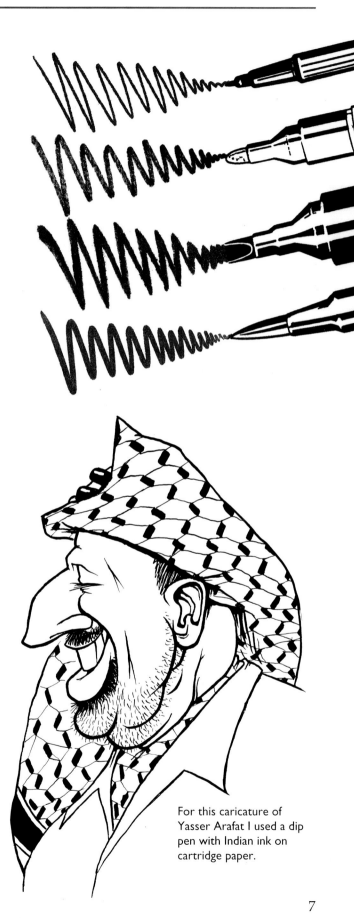

For this caricature of Yasser Arafat I used a dip pen with Indian ink on cartridge paper.

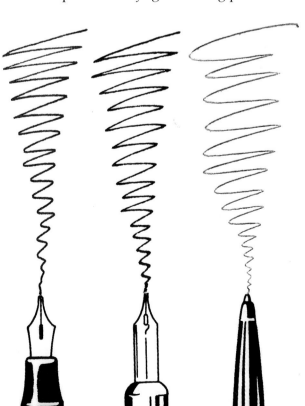

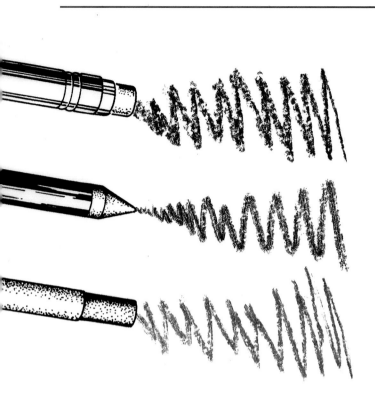

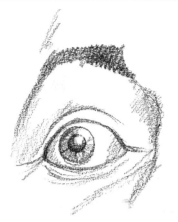
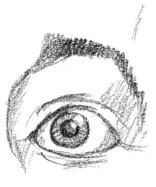

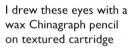

I drew these eyes with a wax Chinagraph pencil on textured cartridge paper, which gives the drawing a sense of the tonal qualities of skin.

Pastels, chalks and crayons

These materials are better suited to textured tonal sketching than the more precise linework provided by pens or pencils and can be used to produce looser, more lively drawings. Generally, the soft powdery lines they produce work most successfully on rough papers. These soft lines can then be smudged and blended with the finger to create the soft tones that are ideal for rendering the warm curves of skin on the face.

You can use **pastels** and **chalks** to create relatively sharp lines by holding them with their tips to the paper, or wide areas of colour by applying them side-on to the paper. They are particularly useful in producing lively drawings full of spontaneous movement, and are available in a wide range of colours and in pencil form for ease of use.

Conté crayons produce a similar effect to pastels and chalks, but because of their more greasy texture they are less prone to crumble. Like pastels and chalks, they are available in pencil form.

Oil-based pastels and **wax crayons** are available in a wide range of vivid colours. Because they have a greasy texture you should plan out what you are going to draw before you start, as they will be difficult to erase. You can rub pastels with your finger to blend colours and soften edges, while wax crayons are best blended by making overlapping cross-hatched lines on the paper. By careful not to blend too much or you will lose the bright colours they provide.

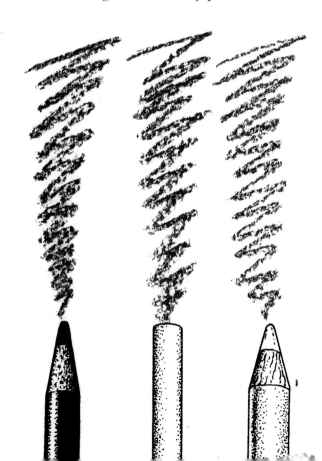

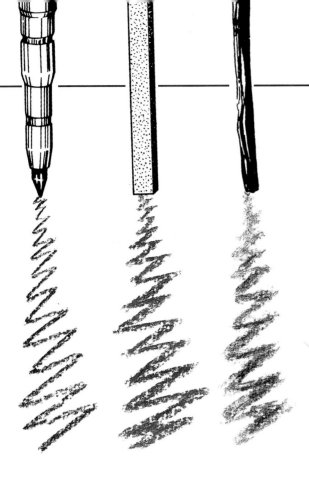

Femi Adetunji smudged charcoal to obtain the soft tones in this caricature of Will Smith.

Artist's Tip

These soft media have a tendency to smudge. This can be used to good effect, but you would be well advised to cover the completed parts of your drawing with a piece of paper to prevent further smudging.

Charcoal is available in many forms including natural charcoal and compressed sticks, and is best used for drawing on a large scale. Because of its particularly crumbly texture charcoal quickly becomes very messy, and it is easy to overwork your pictures.

Highlights and corrections can be easily achieved in charcoal using a soft putty eraser.

Compressed charcoal pencils are also available. They are a bit more manageable and less messy than natural charcoal but they still produce a similar result. However, they give a fine line like graphite pencils and so are probably best used on small-scale works.

Compressed graphite sticks are for all intents and purposes like pencils without the wood surround – they are just composed of solid graphite. Like pencils, they are available in the usual range of soft and hard leads, but their strokes resemble that of a thick pencil. Because they are large they can be used on their side to cover large areas of paper quickly, or sharpened to a point to produce cross-hatched fine lines.

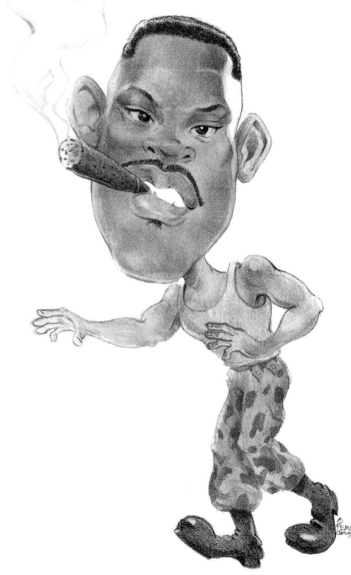

Brushes and wet media

Wet media, used with brushes, can create a wide range of tonal effects. Experiment with a few different paints to discover the one that works best with your style. Brushes are available in a range of sizes and shapes, from fine, pointed brushes for detail work to wide, flat brushes for broad washes. You can also draw with brushes, for a more expressive, lively line than that produced by pen.

It can be tricky deciding which type of brush to use. Sable, considered the best for watercolours, is expensive, though if it is well looked after it should last a long time. Other fibres that are available include squirrel hair, which is better for broad brushes, and synthetic fibres. The latter were originally considered only appropriate for acrylics, though more advanced synthetic fibres suitable for all media are now available. Cheaper

3 For an even layer of strong watercolour, add darker washes to a light wash while still wet.

4 To prevent colours 'bleeding' together, allow the first layer to dry before you add the next.

5 For a soft, blurry effect, apply watercolour to paper that has been slightly dampened.

6 Ink or concentrated watercolour on damp paper will 'flare' and spread into the wash.

watercolour brushes are often made of mixtures of natural hair, or of natural and synthetic fibres. These are generally of poorer quality, but it's worth experimenting with a few different types to find one you are comfortable with.

Brushes require maintenance to extend their life and performance. Wash them regularly and carefully, store them upright and never leave them in water for too long.

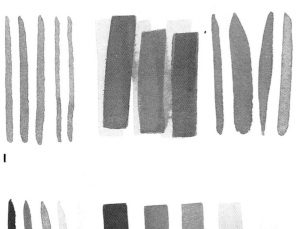

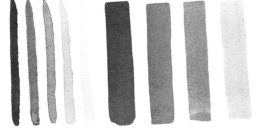

Before you start out it is wise to equip yourself with a palette or tray to mix your colours in, a jar to hold clean water for mixing and another to wash your brushes in, plus a clean cloth to dry them on. It's also worth getting hold of a scrap of paper to test your colours on – sometimes what looks right on your palette dries to a different hue on paper.

1 These marks were made with *(from left to right)* a small round No. 2 brush, a ⅜in flat chisel brush, and a large round No. 12 brush.

2 Watercolour tone can be made progressively lighter by adding more water, as shown by these strokes using different dilutions.

Watercolour is generally used to produce transparent washes or soft tones, but if it is diluted with less water it can produce strong, vivid colours. Watercolour paints can be purchased in a range of forms, most commonly in tubes or pans. Pencil and ink lines will show through the watercolour, so this feature can be used as a technique to strengthen the shape and form of the caricature.

Gouache, or designer's colour, is an opaque water-based paint sold in tubes. Unlike watercolour, its opacity means you can lay a lighter colour over a darker one, and indeed cover up mistakes. However, pencil lines will also be masked by it.

Acrylic is similar to watercolour when diluted. Although it is water-based, when it is used undiluted it yields a result that resembles oil paint, with the advantage of being quick to dry. It is good for building up translucent layers of colour.

Ink is a pigment which can be used with brush or pen for different effects. Inks are generally considered transparent, although it is now possible to get opaque inks, based on acrylics, liquid watercolour inks and waterproof black Indian ink. It is also possible to water down your inks to create lighter washes. Inks are usually spirit- or shellac-based, but it is possible to obtain Chinese sticks which you can mix with water to make your own inks. These are also available pre-ground.

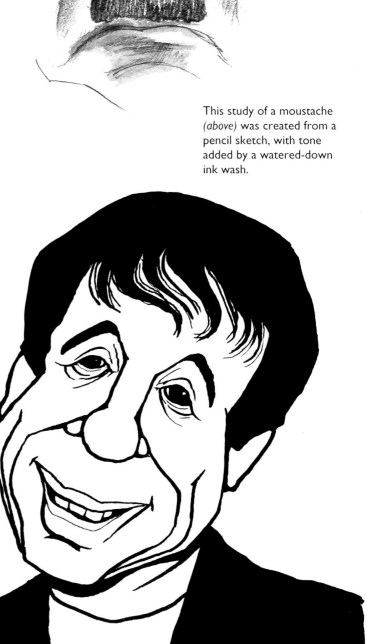

This study of a moustache *(above)* was created from a pencil sketch, with tone added by a watered-down ink wash.

I initially drew this caricature of Paul Simon *(right)* in pencil and then drew over it in black Indian ink using a dip pen. I then filled in the larger black areas with a brush.

Newsprint is very inexpensive, which makes it good for practising and for rough sketching.

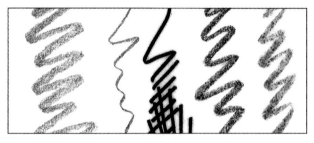

Tracing paper is semi-transparent, so that you can lay it over other images and trace them.

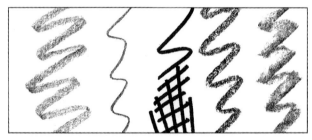

Stationery paper, usually available in standard sizes, has a smooth surface which works well with pen.

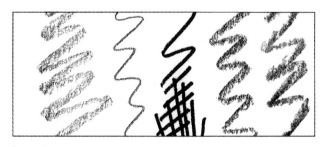

Cartridge paper has a slightly textured surface, and is one of the most versatile surfaces.

Paper

The type of paper or board you choose can have a significant effect on the finished caricature, so it is important to match your choice of media to a suitable surface. Pastels and chalks work best on textured papers, watercolours need a heavyweight paper to avoid wrinkling, and pen and ink moves more easily across smooth paper.

Watercolour paper is generally the most expensive paper on the market. As well as being thick, it often has a very rough texture. It is acid-free, so it will not turn yellow when exposed to daylight.

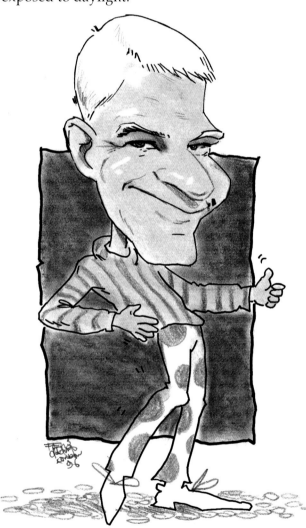

This caricature of American comedian and actor Steve Martin by Femi Adetunji has been created with bright watercolours and pen and ink on watercolour paper.

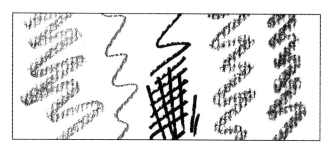

Pastel and Ingres papers, with textured surfaces in many colours, are ideal for pastel, charcoal and conté.

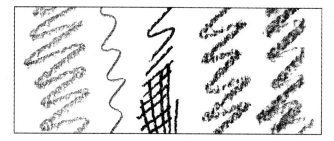

Watercolour paper is absorbent, and can have a rough or smooth surface. It is ideal for wet media.

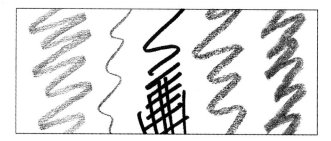

Bristol board has a smooth surface which makes it highly suitable for drawings in pen and ink.

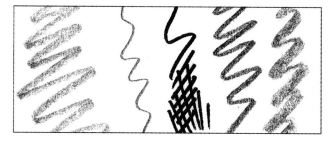

Layout paper is a semi-opaque, lightweight paper which is suitable for both pen and pencil.

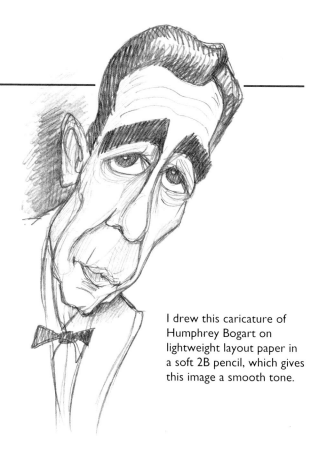

I drew this caricature of Humphrey Bogart on lightweight layout paper in a soft 2B pencil, which gives this image a smooth tone.

Cartridge paper is a good universal surface. It is available in a range of weights and textures, and will work equally effectively with ink and paints as well as pencil, pastel and chalk.

Bristol board is similar to cartridge paper but heavier in weight. It has a smooth surface so is able to take fine detail in pen or brush.

Photocopying paper is a good lightweight sketching paper which can be bought cheaply in large reams, most easily available in A4 size. It takes pencil and ink well, but the lighter varieties do crinkle easily.

Tracing paper is a useful way of lifting shapes and faces from other sources or reversing and flipping images when planning your caricature. It is probably worth looking out for the heavier 90gsm variety rather than 63gsm, as it is significantly easier to work with.

While you can buy paper by the sheet, which may suit you better for the more expensive papers, it is usually easier to buy your paper in blocks or pads, or even hard-covered books. It is a good idea to buy a pocket-sized sketchbook, as you never know when inspiration may strike.

Choosing the Right Medium

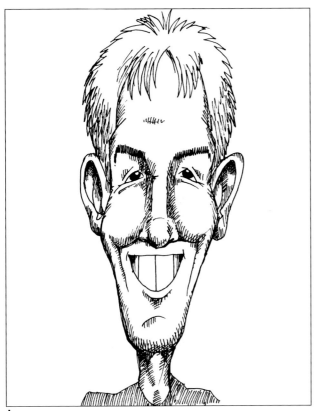

1

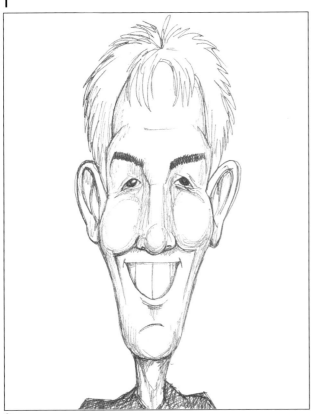

2

You should spend a little while experimenting with mixing media and surfaces. By using different combinations of materials you can create a wide range of moods or effects, depending on the sort of impression you want your caricature to create.

The subject of the drawing and the way you want to depict him or her can also have a bearing on your choice of media. Detailed caricatures are probably best rendered in fine pen or hard pencil, whereas a softer, rounded face may be better in the graduated tones of charcoal or pastel. A political caricature tends to have more impact if done in hard line, a friendly portrait caricature might be best rendered in softer tones on textured paper, while a caricature of an extrovert entertainer could be enlivened with bold blocks of bright colour. Don't be afraid to mix your media, though. Fine details may be added in ink to an otherwise soft-toned watercolour caricature, for example, to add structure to the face.

On this page and the one opposite I have drawn a caricature of the same person in six different combinations of media and surface. Note the different approaches I have taken to applying tone to the caricature, be it the cross-hatching of the technical pen or scribbled ballpoint to smudgier pencil or charcoal. Sometimes I use no tone at all, merely depicting the strength of shadow by thickness of line as in the pen and ink illustration.

With a little practice you should be able to find a combination of media that suits your style of drawing and fits the subject matter you are trying to depict.

1 Technical pen on medium cartridge paper
2 Ballpoint pen on layout paper
3 Soft 4B pencil on cartridge paper

4 Pen and ink on cartridge paper
5 Charcoal on watercolour paper
6 Brush ink and wash on watercolour paper

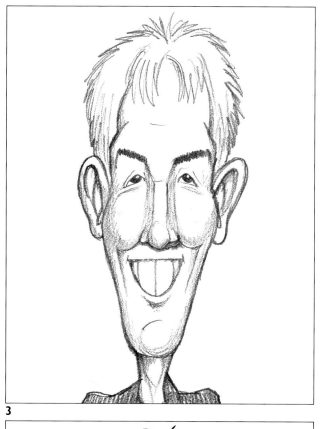

3

5

4

6

What Is Caricature?

What we now know as caricature began in Renaissance Italy, where artists such as Annibale Carracci first drew exaggerated portraits (from where we get the word 'caricature', a derivation of the Italian *caricare*, meaning to exaggerate or load). Caricature can be seen as the art of capturing the essence of someone's personality through an exaggerated likeness, to create a portrait that is ultimately more true to life than life itself. A caricature should be more than just a likeness which merely stretches someone's nose or gives them big ears – it needs to reveal something of the personality behind the face.

The caricaturist's role is to study the subject and discover what makes him or her unique, a combination of appearance and character. Often a caricature is seen as a cruel or grotesque representation, but this misses the point. A caricature does not have to be ugly unless the subject deserves to be ugly; many caricatures can be very subtle and restrained.

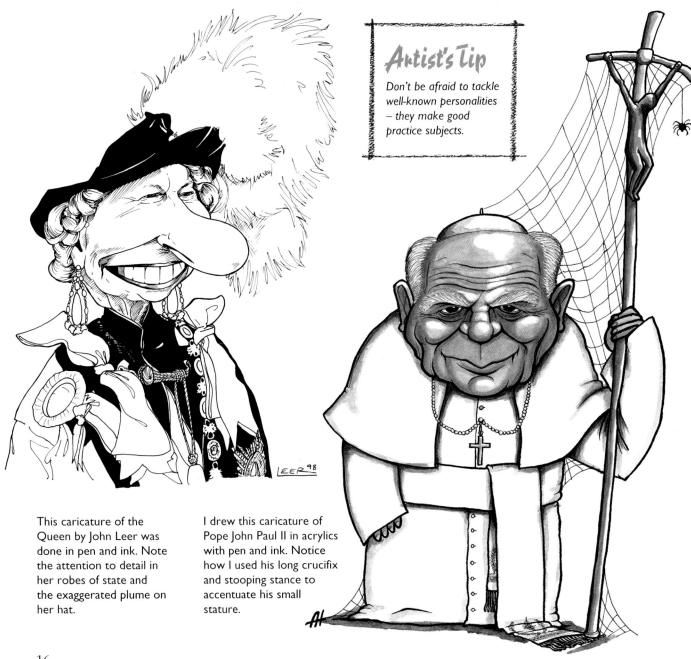

Artist's Tip

Don't be afraid to tackle
well-known personalities
– they make good
practice subjects.

This caricature of the Queen by John Leer was done in pen and ink. Note the attention to detail in her robes of state and the exaggerated plume on her hat.

I drew this caricature of Pope John Paul II in acrylics with pen and ink. Notice how I used his long crucifix and stooping stance to accentuate his small stature.

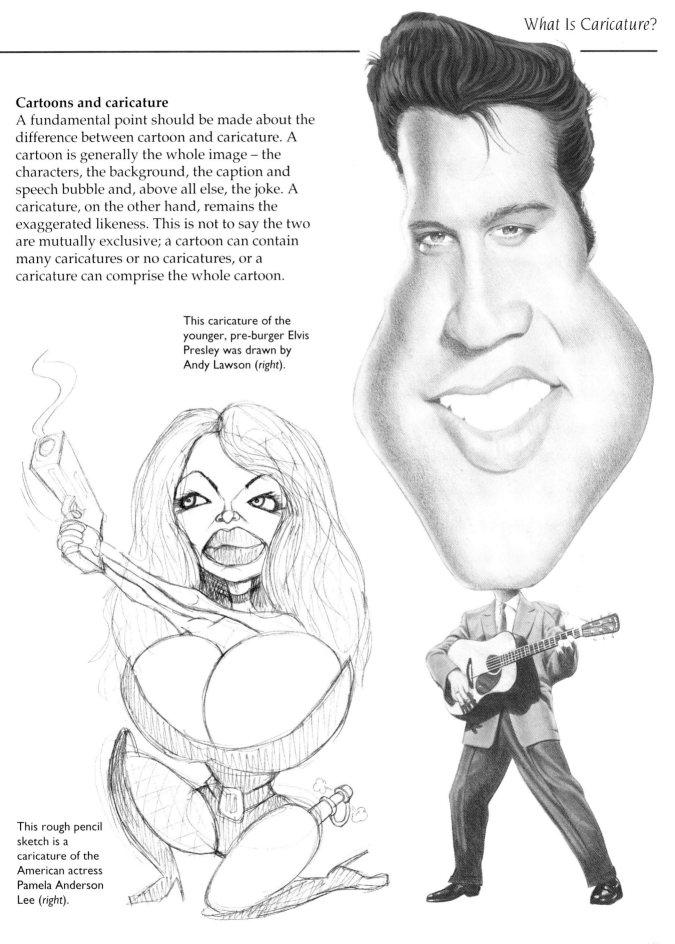

Cartoons and caricature

A fundamental point should be made about the difference between cartoon and caricature. A cartoon is generally the whole image – the characters, the background, the caption and speech bubble and, above all else, the joke. A caricature, on the other hand, remains the exaggerated likeness. This is not to say the two are mutually exclusive; a cartoon can contain many caricatures or no caricatures, or a caricature can comprise the whole cartoon.

This caricature of the younger, pre-burger Elvis Presley was drawn by Andy Lawson (*right*).

This rough pencil sketch is a caricature of the American actress Pamela Anderson Lee (*right*).

Types of Caricature

There are broadly four main styles of caricature: portrait, stylized, quick sketch and political. Each style of drawing has its strengths and weaknesses and you should take care to choose the right style to represent your subject.

Portrait caricature is the most straightforward form of caricature – you just take your subject and draw an exaggerated portrait. This is often the starting point for other styles – your simple portrait caricature can be used as a basis for a political caricature, for example. With political caricature you are attempting to make a joke or comment about your subject. The style of caricature allows you the freedom to be much more malicious about your subject.

Caricatures of celebrities are often highly stylized. Effectively a portrait caricature reduced to simple shapes and lines, this is a tricky but effective form of caricature. Quick sketch or 'live' caricature is more a form of entertainment. The caricaturist usually sketches guests at a party or function. You have to work quickly – there's no room for error.

Stylized caricatures work particularly well with well-known faces, such as Charlie Chaplin, where you can render a simple likeness with the minimum of line *(right)*.

Portrait caricatures such as this one of a friend can be very detailed, and a good caricaturist can bring out the sitter's personality *(above)*.

Quick-sketch caricatures such as this one of a friend require practice, but the results are rarely as well observed as a studied portrait caricature *(right)*.

Artist's Tip

When drawing people from life, you might find it useful to carry a camera with which to record their likeness as a means of cross-checking your sketches.

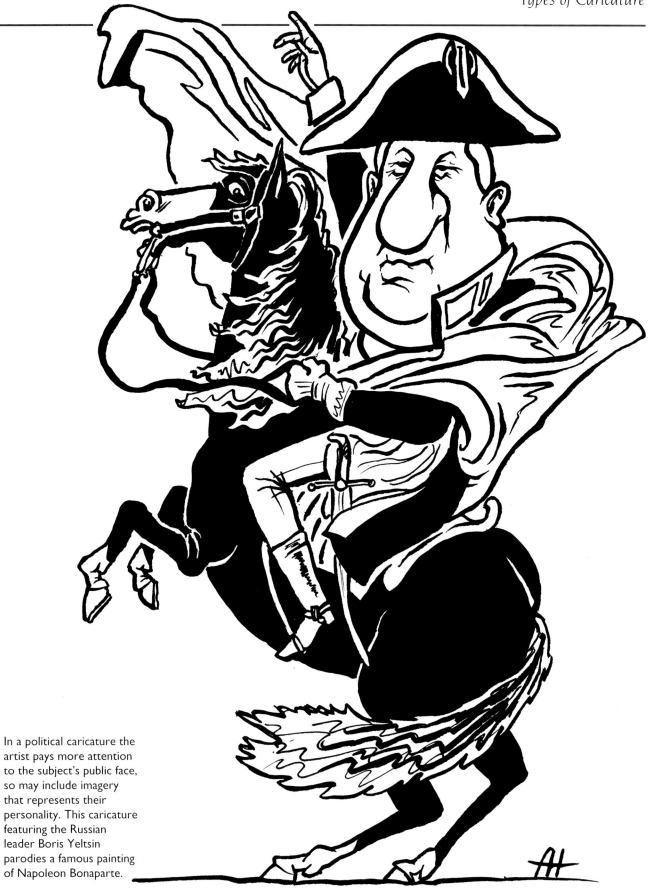

In a political caricature the artist pays more attention to the subject's public face, so may include imagery that represents their personality. This caricature featuring the Russian leader Boris Yeltsin parodies a famous painting of Napoleon Bonaparte.

The Whole Face

Before we move on to specific facial features it would be helpful to understand how these features relate to each other on the face. To see where they fit together normally should help you see how to distort them. After all, a caricature is not just about exaggerating or shrinking those features, but also about the space between them. Bear in mind that most faces are broadly symmetrical and that these proportions are only rough rule-of-thumb measures.

Standard proportions
The width of the whole head is roughly two-thirds the length of the head (A). A line drawn across the face halfway down the head forms a line across the tops of the eyes. The eyes are placed the equivalent of one 'eye' apart, which is also the width of the nose at its widest point across the nostrils. The whole face is also five 'eyes' wide (B). The distance from the brow to the base of the nose is equivalent to the distance

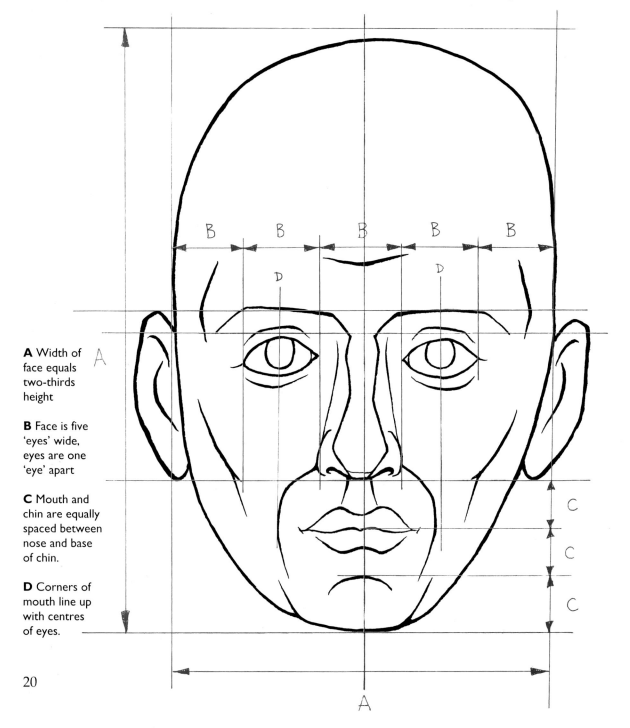

A Width of face equals two-thirds height

B Face is five 'eyes' wide, eyes are one 'eye' apart

C Mouth and chin are equally spaced between nose and base of chin.

D Corners of mouth line up with centres of eyes.

from the base of the nose to the base of the chin (E), while the corner of the jawbone is in line with the corner of the mouth (G).

This space from the base of the nose to the base of the chin can be split equally into thirds (C), the upper third being the upper lip, the middle being from the upper lip to the top of the chin prominence, the lower being to the base of the chin. Also note that a line drawn from the centre of the pupils straight down lines up with the corners of the mouth (D), and a horizontal line drawn from the corner of the mouth will meet the corner of the jaw.

The ear is bounded at the top by a line drawn straight across from the brow, and at the bottom by a line straight from the base of the nose (F). This latter line also crosses the base of the cheek and the base of skull where it meets the neck (H).

E Distance from brow to nose equals distance from nose to chin
F Ears are same length as the distance from brow to base of nose

G Corner of jawbone in line with corner of mouth.
H Base of cheek and base of skull in line with nose and ear.

Face Shapes

Over the next few pages I have illustrated the basic forms and features a caricaturist needs to work with. These will be your fundamental building blocks with which you should be able to construct your finished caricature. I have not listed these as an identikit set, where you pick and mix the features you wish to use. I merely hope to show you the sort of things you should be looking for when studying your subject; the things that make for an interesting caricature.

One of the most obvious characteristics of the human face is its overall shape. For many caricatures this will be your starting point, so it's a good idea to familiarize yourself with a handful of the more common shapes you may encounter.

A square-shaped face normally implies a stocky, solid build.

Someone with a triangular face such as this is likely to have sharp, pointed features.

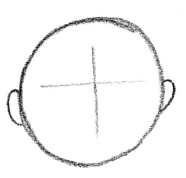

A round face such as this is normally associated with a cheerful personality.

A diamond shape is similar to a triangular face but with a more pointed forehead.

This long, thin face would probably belong to a tall, thin person.

A hexagon such as this can form another stockily built face.

This inverted egg-shape indicates a fat, jowly, double-chinned sort of face.

A trapezoid-shaped face such as this normally goes with a stocky, bull neck.

The owner of a flat, ovoid head such as this may be rather short and a bit fat.

An highbrow egg-head such as this can mean an intellectual, bookish type of personality.

Head angles

There are three basic views one can take of the head, shown here. There are obviously other possible views, but for the caricaturist these are largely going to be irrelevant – it's much trickier to caricature someone from the back of the head, for example. It is important to choose which view to take early on – though this may be decided by circumstances, as it is tricky, if not impossible, to picture someone's profile from a photograph of their full face.

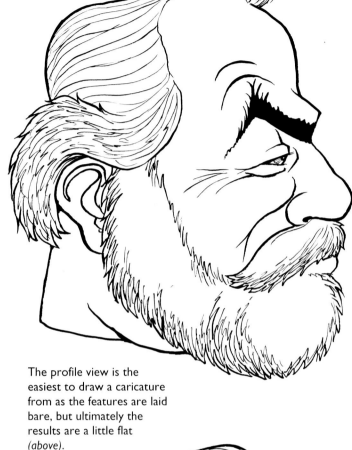

The profile view is the easiest to draw a caricature from as the features are laid bare, but ultimately the results are a little flat *(above)*.

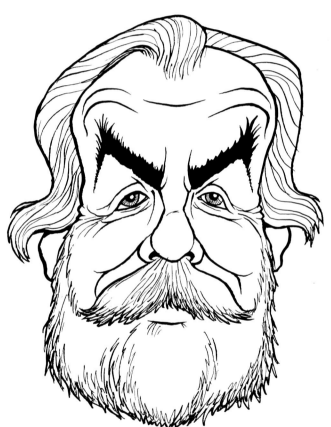

The full face (here of my father) is the most straightforward pose and the easiest to plan out but gives no real scope for depth *(above)*.

The three-quarter profile is probably the most satisfying to draw, as it contains information from both the full face and profile *(right)*.

Facial Features

Because the eyes can tell you an awful lot about a person's character and mood they are often the first thing you look at on meeting someone, and they are therefore the feature it is important to get right. Large irises make the eyes look soft and docile, whereas a small iris surrounded by white can make the subject of the caricature appear surprised, or even mad. Be aware of different kinds of eyelids; some are heavy and overhung, particularly in older people, and will darken the rest of the eye.

Bags, wrinkles and crow's feet can be used to great effect around the eyes. Look out for the way the wrinkles crease across the bridge of the nose, as they are normally quite distinctive. Eyebrows are also important, be they thick and bushy or high fine lines. Remember a lot of expression can be put into eyebrows alone by virtue of their position.

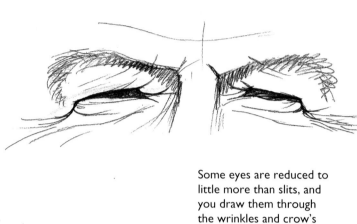

While most eyes appear symmetrical, small imbalances in detail can be played to your advantage (below).

Some eyes are reduced to little more than slits, and you draw them through the wrinkles and crow's feet (above).

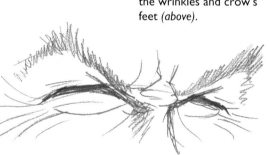

A steely gaze like this combined with a frown presents quite a mean-looking expression (above).

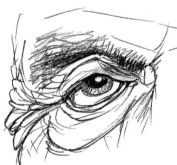

Sometimes bags, eyelids and wrinkles around the eyes can be more interesting than the eyes themselves (above).

With heavy bags under the eyes, most other wrinkles are lost in the sagging skin (right).

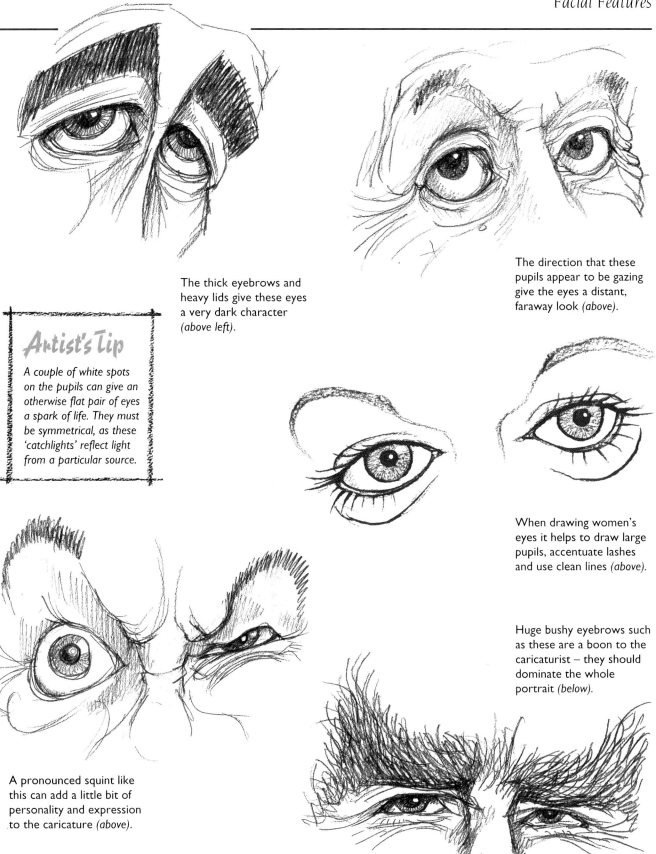

The thick eyebrows and heavy lids give these eyes a very dark character (above left).

The direction that these pupils appear to be gazing give the eyes a distant, faraway look (above).

Artist's Tip

A couple of white spots on the pupils can give an otherwise flat pair of eyes a spark of life. They must be symmetrical, as these 'catchlights' reflect light from a particular source.

When drawing women's eyes it helps to draw large pupils, accentuate lashes and use clean lines (above).

Huge bushy eyebrows such as these are a boon to the caricaturist — they should dominate the whole portrait (below).

A pronounced squint like this can add a little bit of personality and expression to the caricature (above).

Eyes and glasses

A section on eyes would not be complete without mentioning glasses, which of course can have a dramatic effect on a caricature. Remember that thick lenses can magnify or reduce the apparent size of the eyes behind the glasses, and this can be caricatured accordingly.

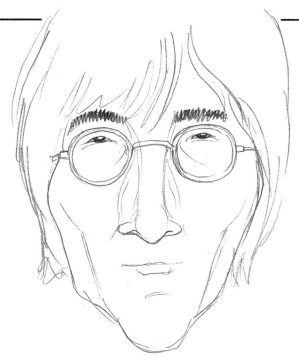

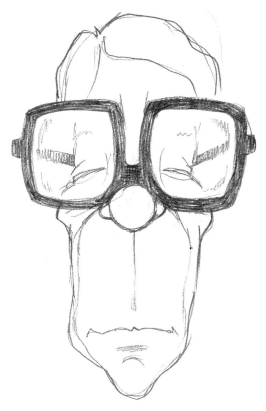

Small, round glasses such as John Lennon's can reduce the eye size in relation to the rest of the face *(above)*.

Bear in mind the relation between eyebrows and glasses; some people's brows rise above the frames *(right)*.

Glasses with thick frames and lenses such as John Major's dominate the face, so a caricaturist can make them much bigger *(above)*.

Half-moon spectacles such as these can make the wearer appear to be looking down on people in disdain *(below)*.

Remember that glasses are also reflective – a blob of white can make the lenses appear a bit more lifelike *(below)*.

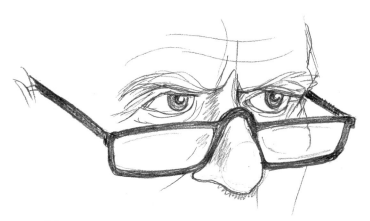

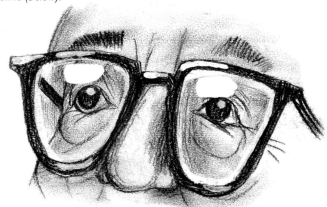

Noses

The nose is often the most strikingly obvious feature on someone's face. From long aquiline beaks to fat bulbous blobs, there is tremendous scope in the nose for the caricaturist. If you are drawing someone who is particularly famous for their nose, it can be worth exaggerating it a little further to comic effect.

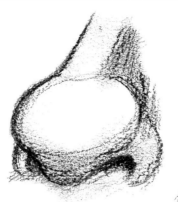

A large, bulbous nose can dominate your caricature *(above)*.

This nose may be bulbous, but don't ignore its pinched bridge *(above)*.

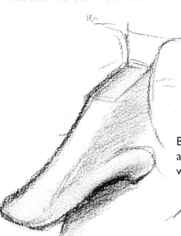

Broken and crooked noses are interesting features to work with *(below)*.

Some people have small, insignificant snub noses such as this *(above)*.

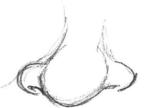

Nostrils can be an especially interesting feature on some noses *(above)*.

A long ski-slope of a nose sticks out quite prominently *(above)*.

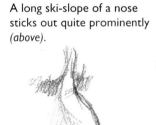

Note the triangular form of the nose; there are fleshier bits to the side above the nostrils *(left)*.

Take a good look at the bridge of the nose – it can hold some interesting features *(above)*.

In these two sketches of Charles de Gaulle you can see how a fairly straight caricature of his large nose *(right)* can be extended into a far more caricatured hooter *(far right)*.

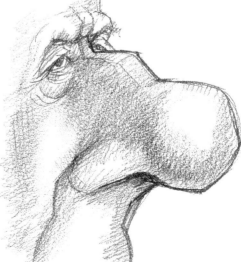

Mouths

You can communicate a lot with your mouth without actually speaking. The shape of someone's mouth can express a lot about their mood, be it happy, sad, angry or thoughtful.

The lower lip is generally more prominent than the upper. The teeth are generally less than perfectly arranged. A crooked incisor, a gap between the front two teeth or even a whole graveyard to bad dental hygiene are worth homing in on for the caricaturist.

The lines and dimples that frame the mouth are worth paying attention to. A prominent *philtrum* (the lines from below the nose to the upper lip) should be played up. Notice the distances between the base of the nose and upper lip and between the lower lip and base of the chin to get accurate placement of the mouth.

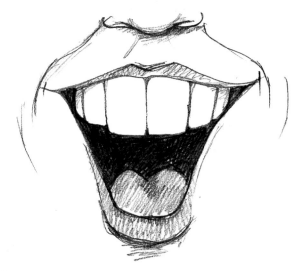

When drawing an open mouth, pay attention to the appearance of the tongue.

In rare cases the upper lip is non-existent. Note the prominent philtrum.

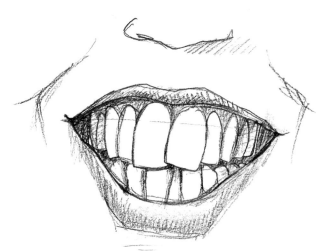

Even an otherwise perfect smile may be blighted by a crooked tooth.

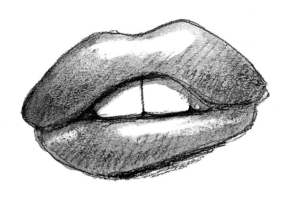

Lipstick gives women's lips a tone and sheen, not to mention body.

Jaws, chins and necks

To round off the lower part of the face we come to jaws, chins and necks. The jaw seems to take more of a battering by nature than other features, developing saggy jowls or double chins. Some men try to hide this by covering their lower face with beards and moustaches.

A bushy or unusual moustache can act as an identifying feature in its own right *(above).*

A deep double chin like this makes the whole face look round or even oval *(above).*

A broad, powerful neck like this supports a chiselled chin and jutting jaw *(right).*

Older men can tend towards deep folds of wrinkled jowls or even dewlaps around the chin *(above).*

A bushy beard such as this example dominates the lower face and should be exaggerated *(below).*

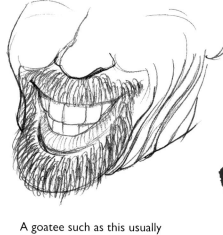

A goatee such as this usually fails to cover the wrinkles around the chin *(above).*

This caricature of television presenter Jeremy Beadle by Jonathon Cusick plays up his neatly trimmed beard *(right).*

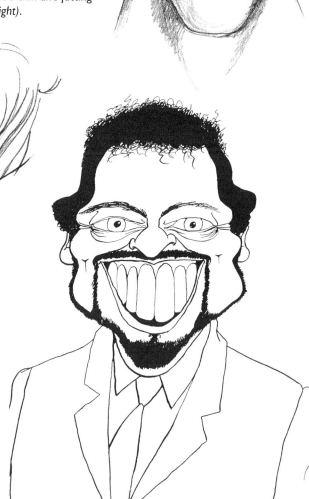

Ears

From the point of view of the caricaturist, most ears fall broadly into two categories: big, sticking-out jug ears, and small insignificant ones. There can be a wide range of shapes and forms within these categories, with pointed ears, large fleshy lobes and so forth, but ears are only of particular interest to the caricaturist when they jut out prominently.

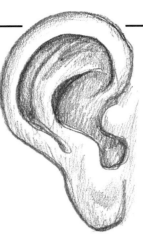

Big ears such as these *(above)* deserve attention to detail.

Most ears need no more detail than these fairly standard forms *(left)*.

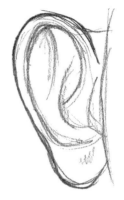

Sticking-out ears can have different shapes *(above)* –

compare these with the pair at the top, for example.

Cartoon-style ears such as these can be quick and easy to draw *(above)*.

Remember that some people wear their hair over their ears *(above)*.

Lobes can be large even if the rest of the ear does not protrude *(above)*.

Another aspect of ears that should concern the caricaturist is that of earrings and studs such as these examples *(right)*.

Some ears can be virtually flat against the side of the head *(left)*.

Hair

Finally, we come to hair. Because of the wide range of potential styles and cuts it would be foolish to try to cover this subject in depth. However, wild, ridiculous and unusual styles are worth picking out for particular attention, and can form the most significant feature of an otherwise bland face.

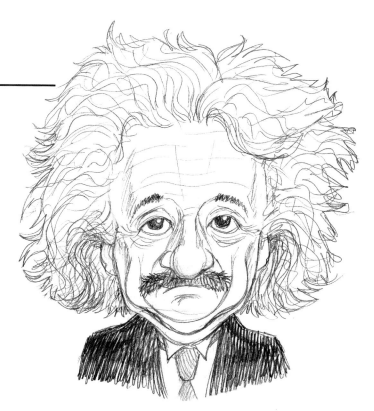

I have used Albert Einstein's notoriously wild hair and high forehead as dominating features in this caricature.

Baldness is a style in itself – note how on some people it elongates the forehead *(above)* while in others it visibly squashes it *(below)*. Try to highlight embarrassing styles; 'combovers' and wigs should be accentuated.

Artist's Tip

If you are really struggling without success to get someone's hair to look just right, you can always contrive a way to cover it with an appropriate hat.

With some women's styles such as perms, following the exact shape and line of the hair can be complicated.

Basic Expressions

What good is drawing a caricature if it has only a blank face? You need your caricature to have some sort of expression, and it helps to see exactly what happens to the face as it reacts to emotions. Remember too that caricatures are exaggerated, so the expressions they wear should also be extreme.

A good exercise is to sit in front of a mirror and practise a few expressions – see what moves and what doesn't. Identify new wrinkles and creases that appear. Subtle alterations in movement can create radically changed expressions with wholly different interpretations. Try making lots of quick sketches such as the ones on these pages to understand how the whole face is influenced by emotions.

Note the way the view and position of the face changes with expression. Happy, smiling faces look up, while sad, angry and grumpy faces are inclined downwards. Also note subtler things, such as the position of the pupil and eyebrows and the turn of the mouth.

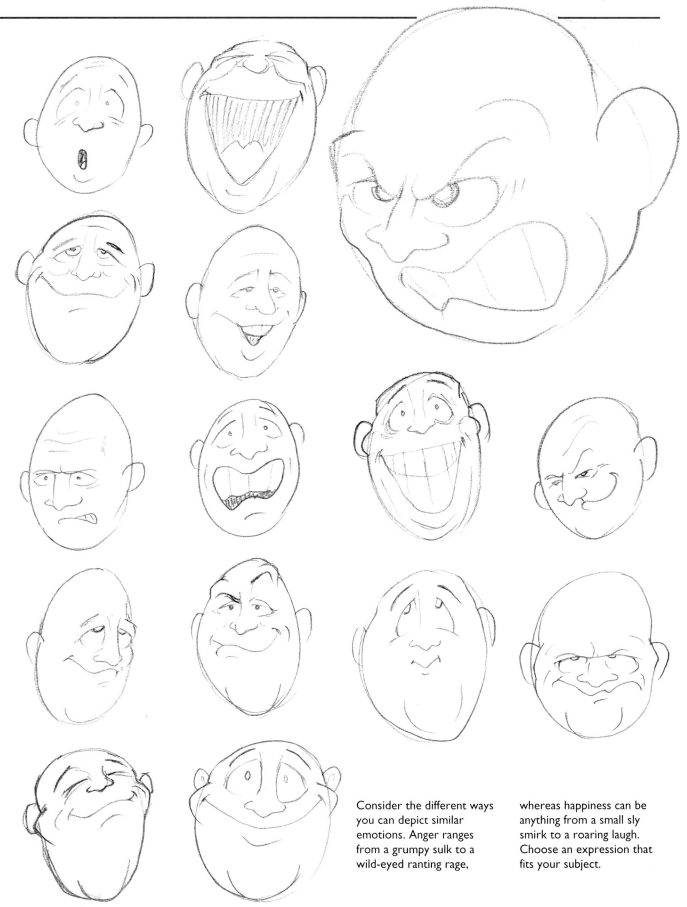

Consider the different ways you can depict similar emotions. Anger ranges from a grumpy sulk to a wild-eyed ranting rage, whereas happiness can be anything from a small sly smirk to a roaring laugh. Choose an expression that fits your subject.

Portraying Personality

A good caricature should amount to more than the sum of its parts. What distinguishes a good caricature from a well-observed portrait is some acknowledgement of the subject's personality. If there is a trick to caricature, then it is capturing that particular spark of life that uniquely summarizes the subject's character. How you do this is harder to quantify, but it involves studying your subjects very carefully.

Watch for the quirks when they express themselves, look out for the way they hold their heads and note the expression that they use most often. You could even try to do impressions in front of a mirror to help you to understand how their face moves.

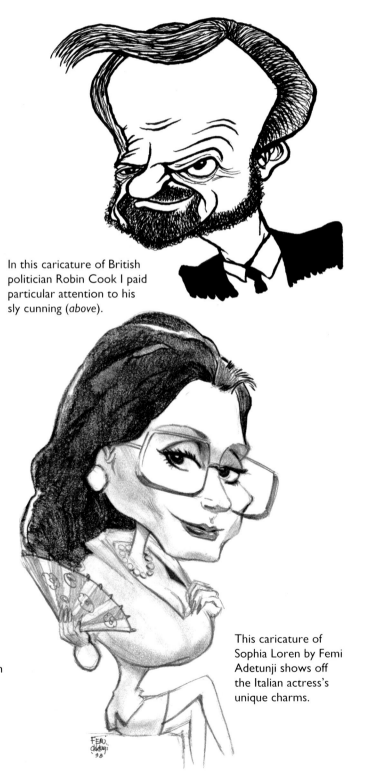

In this caricature of British politician Robin Cook I paid particular attention to his sly cunning (*above*).

In this caricature Andy Lawson captures American movie star Bruce Willis's trademark laidback smirk.

This caricature of Sophia Loren by Femi Adetunji shows off the Italian actress's unique charms.

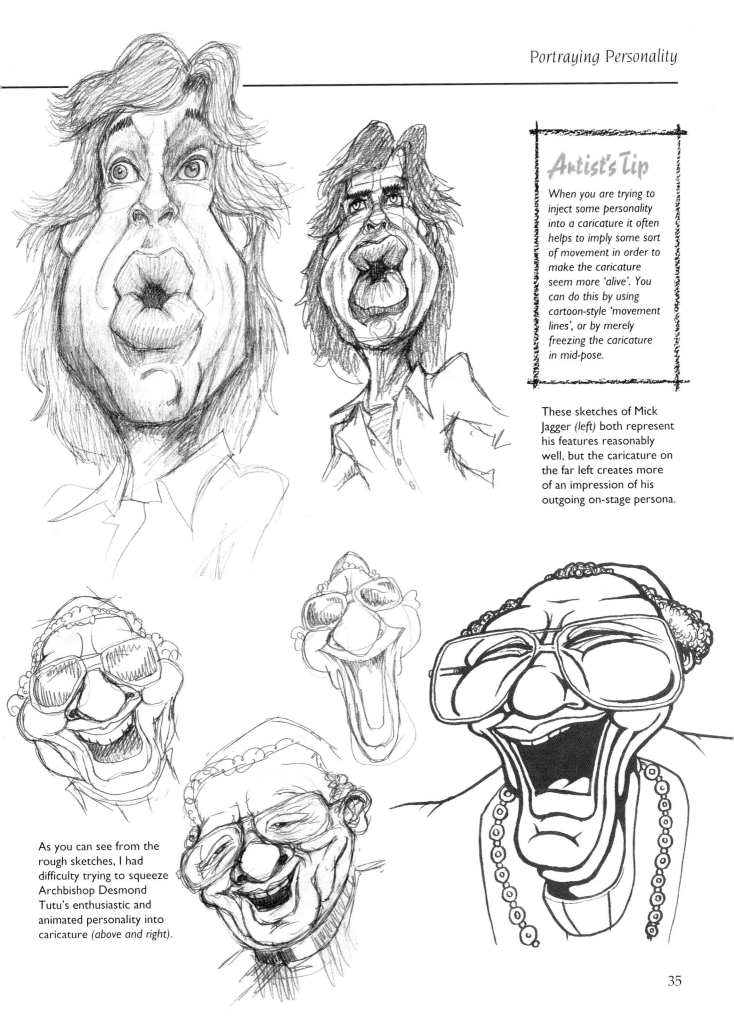

These sketches of Mick Jagger *(left)* both represent his features reasonably well, but the caricature on the far left creates more of an impression of his outgoing on-stage persona.

As you can see from the rough sketches, I had difficulty trying to squeeze Archbishop Desmond Tutu's enthusiastic and animated personality into caricature *(above and right)*.

Working from Photographs

When you are drawing a caricature you rarely get the luxury of working with a live model. While this can be a handicap, at the same time it can be a bonus; photographs can't look the wrong way or complain that you've made their nose too big or eyes too small. However, it is important to pick your source material carefully. As a caricaturist, you should maintain an extensive file of newspaper and magazine photographs of the politicians and celebrities you are called upon to draw.

The best advice is to collect as many pictures as possible of the subject and select the cream of these to work from. Often you will find yourself working from one or two pictures for the larger part of a caricature, using other photographs just to pick out specific details and features.

For this section I gave these photographs of a friend (who probably regrets it now) to some of the other contributors to this book to see how different caricaturists would approach a portrait of the same person.

In this portrait Femi Adetunji delivers a bright, lively caricature of my friend *(below left)*.

Here, Gary Dillon chose to do a relatively studied caricature. Note the attention to detail in the hair *(right)*.

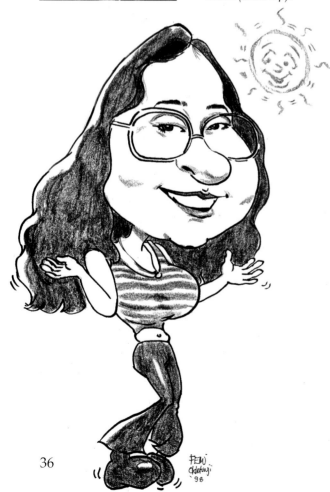

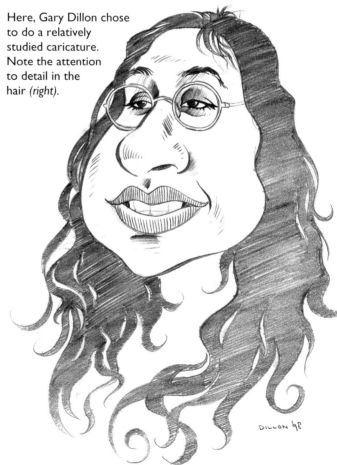

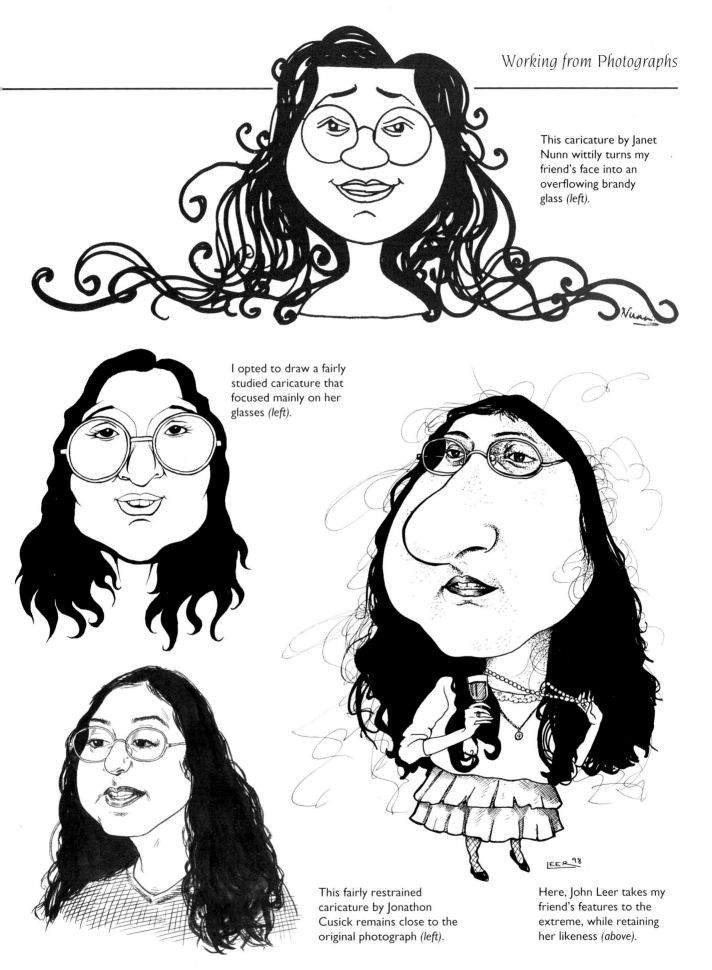

This caricature by Janet Nunn wittily turns my friend's face into an overflowing brandy glass *(left)*.

I opted to draw a fairly studied caricature that focused mainly on her glasses *(left)*.

This fairly restrained caricature by Jonathon Cusick remains close to the original photograph *(left)*.

Here, John Leer takes my friend's features to the extreme, while retaining her likeness *(above)*.

Getting Started

The profile is probably the easiest place of all for a beginner to embark upon doing a caricature because the features can be more or less exaggerated straight out from the normal silhouette outline. However, as is demonstrated in the two sequences of drawings shown below, there is a crucial difference between drawing a true caricature and just 'stretching' someone's facial features.

It is a useful exercise to practise this method of distorting a face. Take a photograph showing

1 This straight profile portrait is the starting sketch.

2 This profile has been stretched a little, but it nevertheless closely resembles the original.

3 The stretching seems to be working – the nose is certainly sticking out prominently. The brow and lips are a bit pronounced.

4 Here the nose still looks good, but the eyes and mouth are overstretched.

5 Here I've reattached the back of the head. As you can see, the portrait works after a fashion, but it feels a little odd.

1 In this version I'm attempting a less linear stretching – again a gradual start that would pass as a portrait.

2 I'm still using the nose more or less as above, but I've added a bit of a curl to the lips.

3 Here I've exaggerated the height of the hairline and given a bit more shape to the end of the nose.

4 The finished caricature. In contrast with the final sketch in the sequence above, this one still looks like the subject.

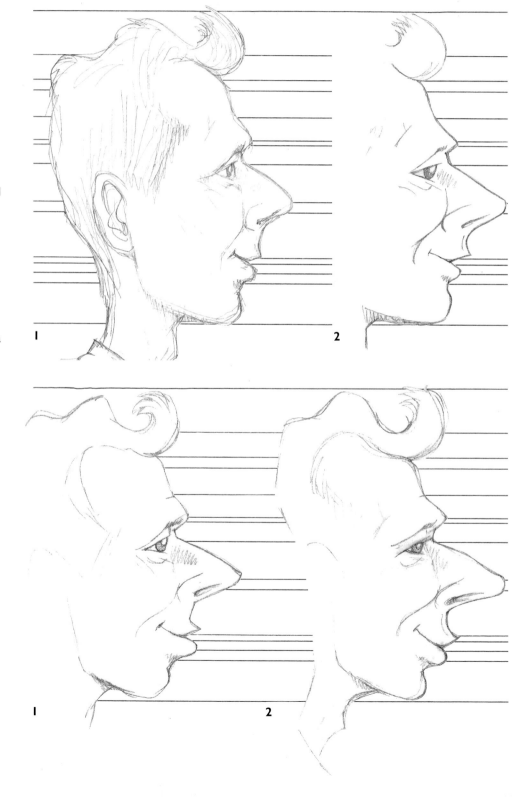

someone in profile, place some tracing paper over it and draw parallel lines across from the key intersection points. Next draw ever-more extreme versions across the page, based on the initial profile. With a bit of practice you will soon see that some features benefit by not being stretched as far, while some features are improved upon for your purposes by being squashed back. However, this method still does not actually produce a 'true' caricature, because the stretching of the features remains quite linear.

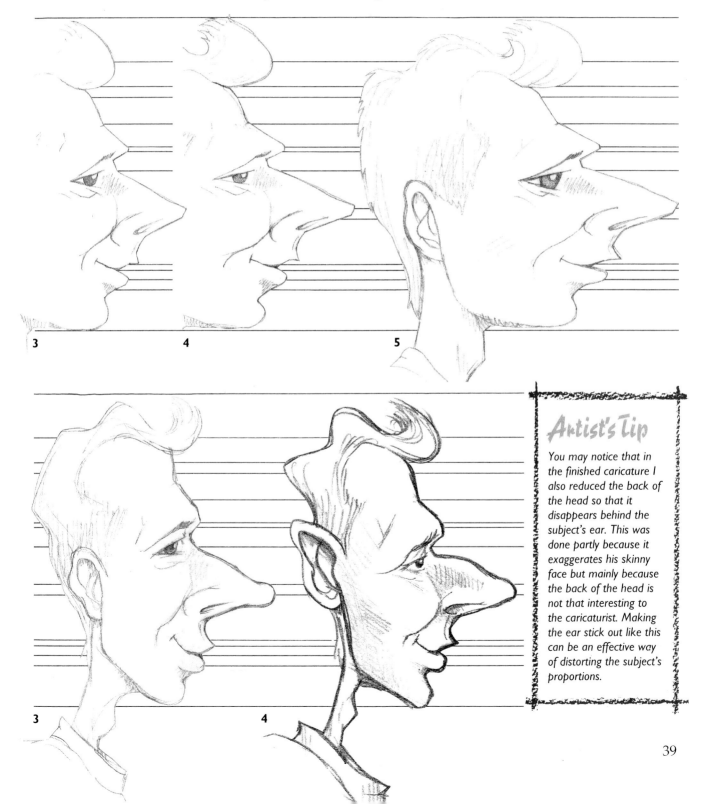

3 4 5

3 4

Artist's Tip

You may notice that in the finished caricature I also reduced the back of the head so that it disappears behind the subject's ear. This was done partly because it exaggerates his skinny face but mainly because the back of the head is not that interesting to the caricaturist. Making the ear stick out like this can be an effective way of distorting the subject's proportions.

Three-quarter view

The three-quarter view is probably the most satisfying to draw for a caricaturist as it is this view that gives a truly three-dimensional feel to a face. Here I show how far you can take a caricature by exaggerating a face stage by stage.

This is not necessarily how you would work, but these drawings do demonstrate the choices you could make in creating a caricature. Note not only the differences in size of the features, but their positioning on the face and the distance between them, which can be as important.

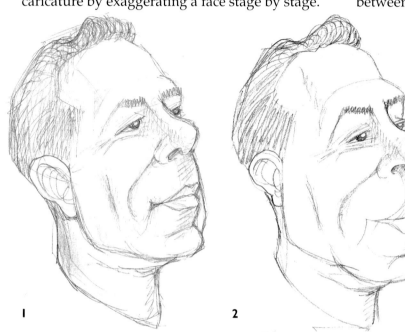

I

2

3

I This starting sketch is again a straight portrait. He has quite a strong line to his features, which helps.

2 In this sketch I have made his nose a little larger, his chin longer and his lips a little fuller.

3 By this stage his eyes are narrowing and shrinking and his jaw is becoming wider. Note the ear sticking out.

4 Here the whole jaw is quite broad, his nose is quite fleshy and his mouth is becoming quite protracted.

5 The final caricature. Notice how the focus of the caricature is predominately on the lower half of the face and jaw.

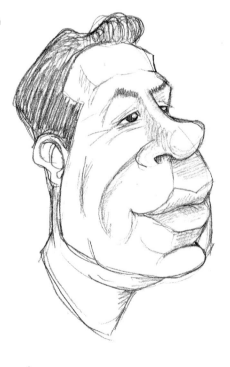

4

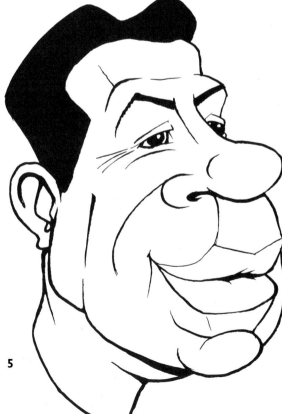

5

Full face

The caricature you will probably be most often called upon to draw is the full-face portrait. It is important to remember that in full face most of the features tend to flatten back, so it is difficult to give that truly rounded form to the caricature.

Still, there is much that can be done from this angle, and it can in fact be somewhat easier to position the various features more effectively than in a profile drawing. As before, I have produced a series of ever-more extreme caricatures as an example.

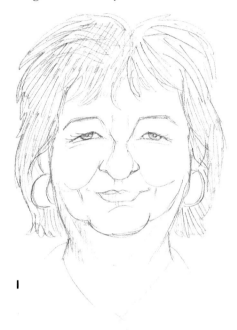

1 Starting as before, with a fairly straight portrait (this time of my mum, so I hope she won't be too offended).

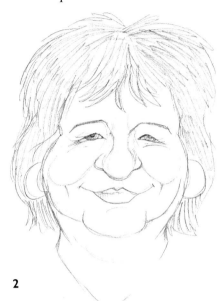

2 Not far in, but already I have narrowed her forehead and widened her cheeks. Her nose is a little fleshier, too.

1

2

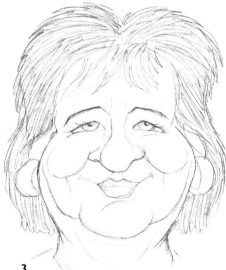

3

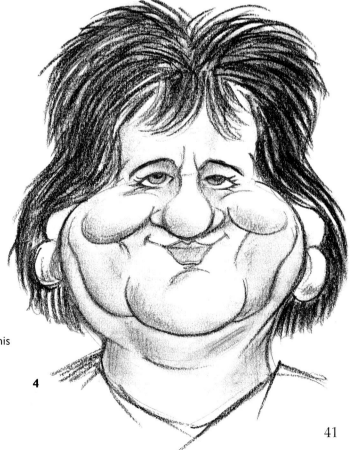

3 Here I am a bit further on. The lips are a little more pronounced and I am also exaggerating her double chin (sorry mum!).

4 The final caricature. I have possibly taken this a little too far, but the likeness still stands up quite well.

4

Approaches to Caricature

Over the course of the next few pages I shall take you through three of the most commonly used approaches to drawing a caricature from scratch. The first method is outline-led, which takes its lead from basic portrait drawing by starting with just the bare outline of the subject's face.

First you need to decide upon the shape of your intended subject's face. Next, following the proportions given on pages 20–1, pencil in approximately where the features should go, bearing in mind that this is a caricature rather than a true-to-life portrait.

Now roughly outline the eyes, nose, ears, hair and mouth. By this stage you should have a fairly reasonable sketch portrait that is slightly exaggerated. Now attack it with an eraser. You should have a good idea what to move and where to move it, so don't be afraid to break the outline rules you drew in earlier.

1 For this example I caricatured Prince Charles. He has a long, thin face, so I started with a corresponding outline.

2 Next I added his features, paying special attention to those famous ears. Notice they are still in proportion to his nose.

3 Fleshing it all out a little, I obtained a portrait with his ears, nose and hairstyle somewhat exaggerated.

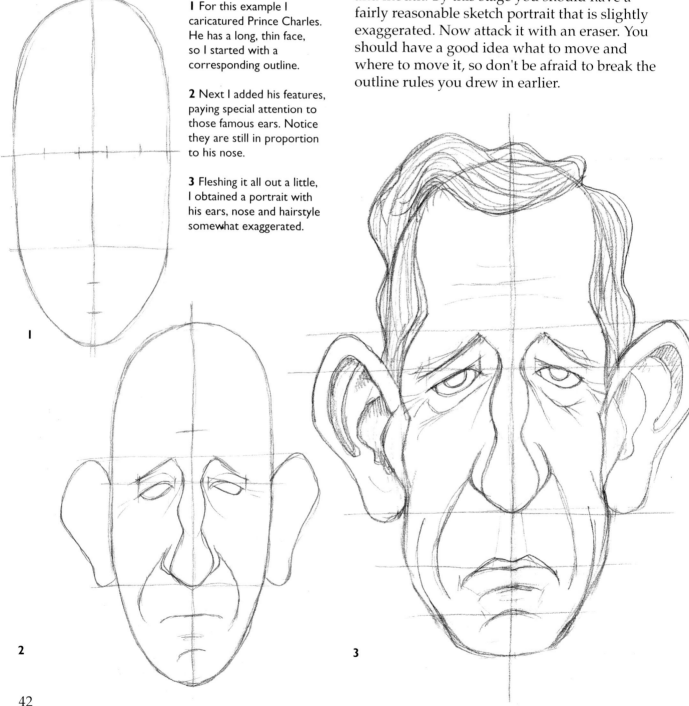

4 Using an eraser, I narrowed his eyes and forehead and enlarged his ears and nose, also stretching his jowls.

5 The final caricature, drawn in pen and ink. I have tinkered with his nose and cheeks a little more in the process.

4

5

Artist's Tip

As there are likely to be a lot of alterations before you get to your final caricature it is a good idea to do all of your rough work with pencil and eraser. Having completed your sketch, you can either ink over it or copy the caricature to a separate sheet to finish the artwork in another medium.

43

Feature-led caricatures
For this method, rather than beginning with the whole face I start with an individual feature and work out from it. Some people have one facial characteristic that stands out more than any other, and it sometimes helps to start there. Big noses, heavy-framed glasses and wide, expressive mouths are good starting points,

whereas features such as ears or hair are tricky to build out from.

You will still need to tinker as you go on, though, and it helps to bear in mind the ratios and proportions for the rest of the face. This is more of a trial and error method of drawing a caricature than the outline-led method.

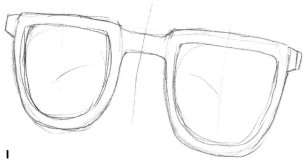

1

1 For this caricature of Woody Allen I started with his distinctive, heavy framed glasses.

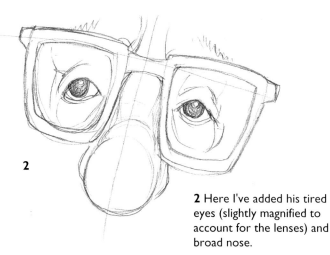

2

2 Here I've added his tired eyes (slightly magnified to account for the lenses) and broad nose.

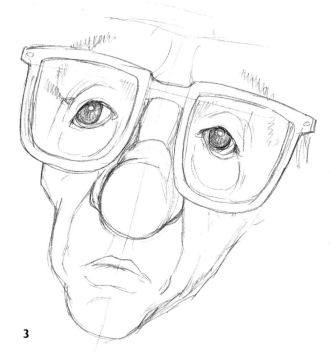

3

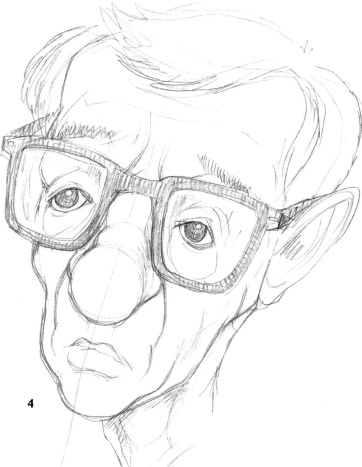

3 The next step in the caricature was to flesh out Woody's craggy yet skinny mouth and chin.

4 I then topped it all off with a broad forehead. Note the triangular form to his face.

4

44

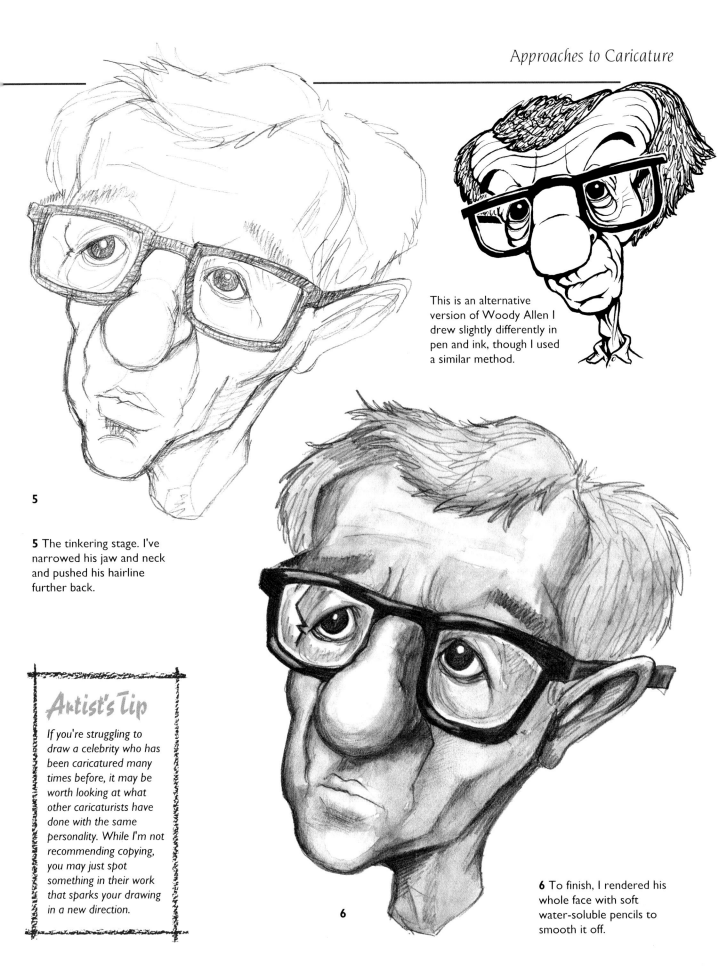

This is an alternative version of Woody Allen I drew slightly differently in pen and ink, though I used a similar method.

5

5 The tinkering stage. I've narrowed his jaw and neck and pushed his hairline further back.

Artist's Tip

If you're struggling to draw a celebrity who has been caricatured many times before, it may be worth looking at what other caricaturists have done with the same personality. While I'm not recommending copying, you may just spot something in their work that sparks your drawing in a new direction.

6

6 To finish, I rendered his whole face with soft water-soluble pencils to smooth it off.

Quick sketch method

This is a good method for tackling someone with an especially animated personality. The idea here is to get as many photographs of your subject as possible and sketch a lot of quick thumbnail-sized drawings. Try different poses, angles, expressions, small studies of particular features and so forth. You should find as you go on that you are picking up certain characteristics from one sketch to the next.

From these you can build up a pretty good idea in your mind of the overall shape of the subject's face and how it moves and flexes under the influences of different emotions. The idea then is to compose your finished caricature from a combination of these sketches, incorporating a bit from this one, an element of that one. With practice you will be able to produce lively caricatures that capture plenty of the subject's personality.

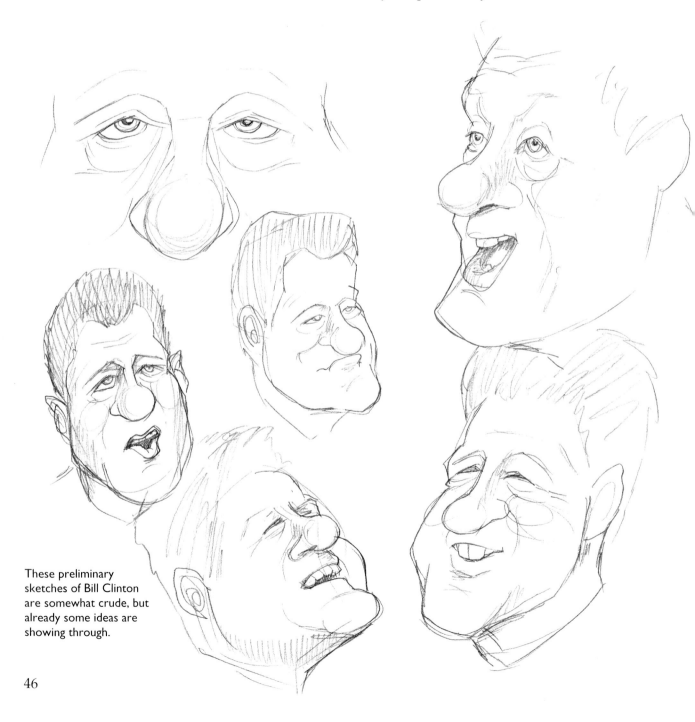

These preliminary sketches of Bill Clinton are somewhat crude, but already some ideas are showing through.

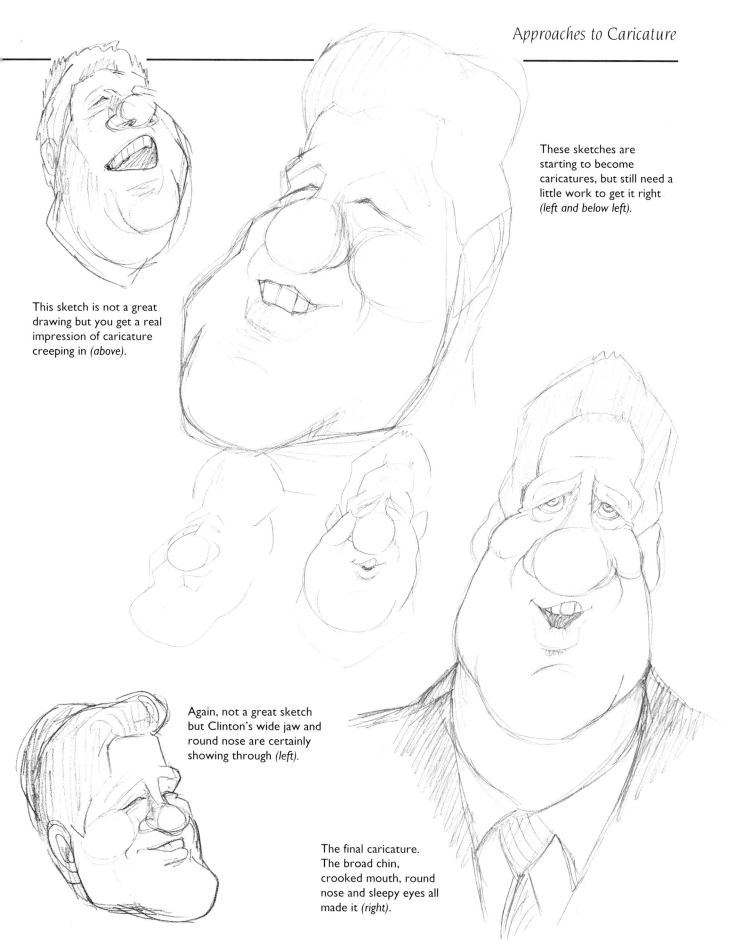

These sketches are starting to become caricatures, but still need a little work to get it right *(left and below left)*.

This sketch is not a great drawing but you get a real impression of caricature creeping in *(above)*.

Again, not a great sketch but Clinton's wide jaw and round nose are certainly showing through *(left)*.

The final caricature. The broad chin, crooked mouth, round nose and sleepy eyes all made it *(right)*.

Working from Life

Usually you would use your live model to make rough sketches from which you can later make a complete caricature. Most people are aware of their more distinctive features, so if they know they are being drawn for a caricature they tend to try to hide them. As you are attempting to capture their personality as well as their appearance you should encourage them to relax, and as they let their guard down you can pick up these otherwise hidden characteristics.

You can also try your hand at so-called 'live' caricature, or drawing quick caricatures while they wait. This can be tricky but can be good practice at spotting caricaturable features without putting much thought into it.

Most people sit down and take on a fixed pose, so you should talk to your subject to put them at their ease *(right)*.

When making quick sketches it is a good idea to add short notes for use later in the finished artwork *(below)*.

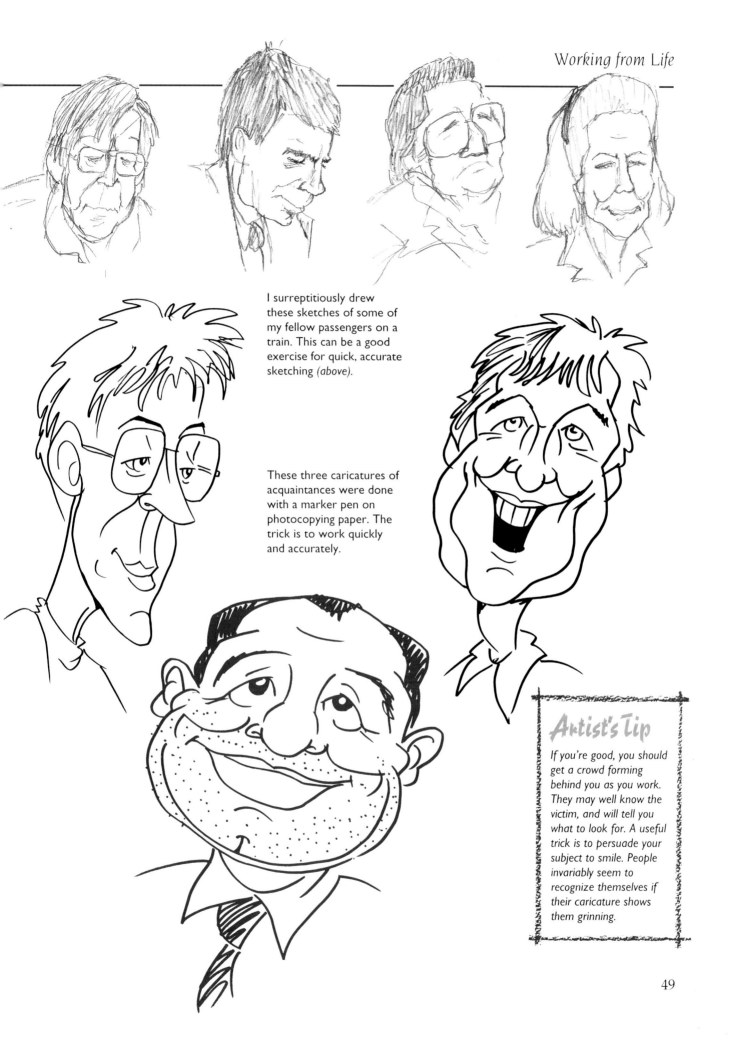

I surreptitiously drew these sketches of some of my fellow passengers on a train. This can be a good exercise for quick, accurate sketching (above).

These three caricatures of acquaintances were done with a marker pen on photocopying paper. The trick is to work quickly and accurately.

Artist's Tip

If you're good, you should get a crowd forming behind you as you work. They may well know the victim, and will tell you what to look for. A useful trick is to persuade your subject to smile. People invariably seem to recognize themselves if their caricature shows them grinning.

Cheats and Tricks

Sometimes, no matter how hard you try, you just can't get a caricature to work. It is for this reason that most caricaturists have a few tricks up their sleeve for just such an eventuality. The results are rarely particularly impressive, but they may trigger an idea of how to tackle the caricature. A basic tip is to try tracing an outline of the subject's features on tracing paper, or, simplest of all, just take a break and come back and try again later.

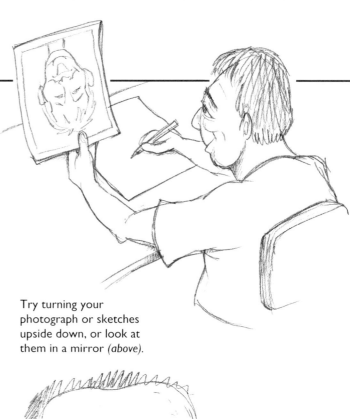

Try turning your photograph or sketches upside down, or look at them in a mirror *(above)*.

If the features look right but are spaced badly, try cutting up the drawing and shuffling the bits around *(right)*.

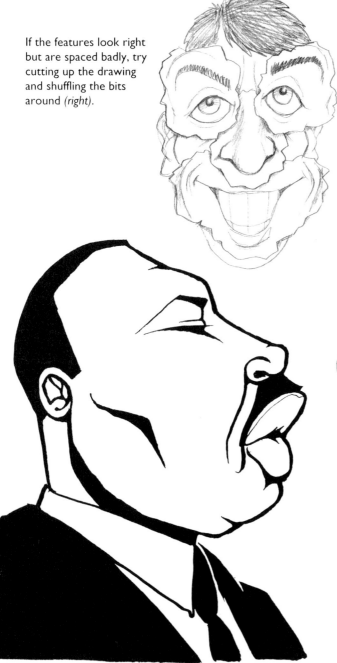

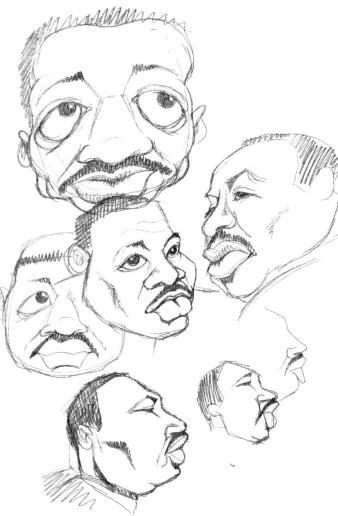

Try a different angle. I had trouble getting Martin Luther King to appear truly statesman-like, so I hit upon drawing him in profile, and it worked *(left and above)*.

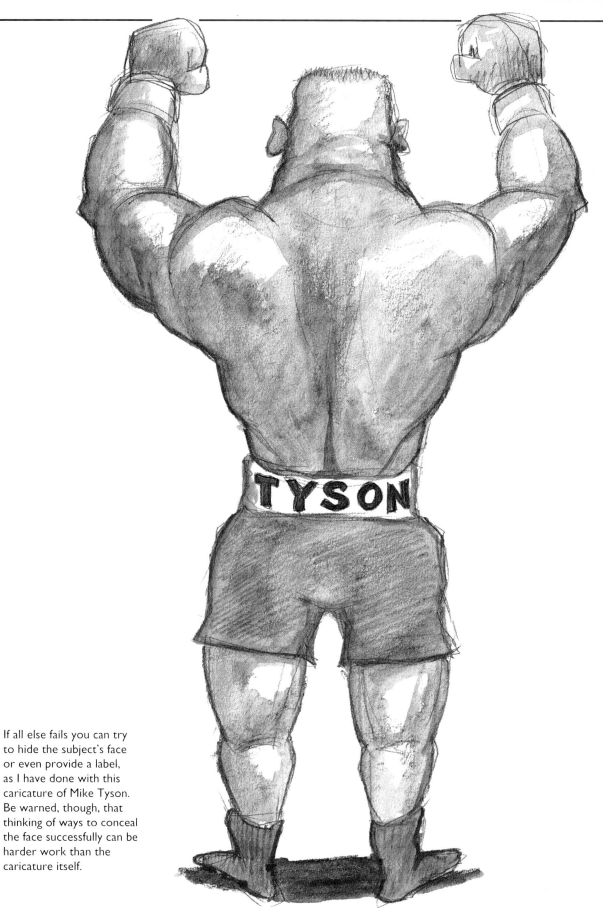

If all else fails you can try to hide the subject's face or even provide a label, as I have done with this caricature of Mike Tyson. Be warned, though, that thinking of ways to conceal the face successfully can be harder work than the caricature itself.

Body Shapes

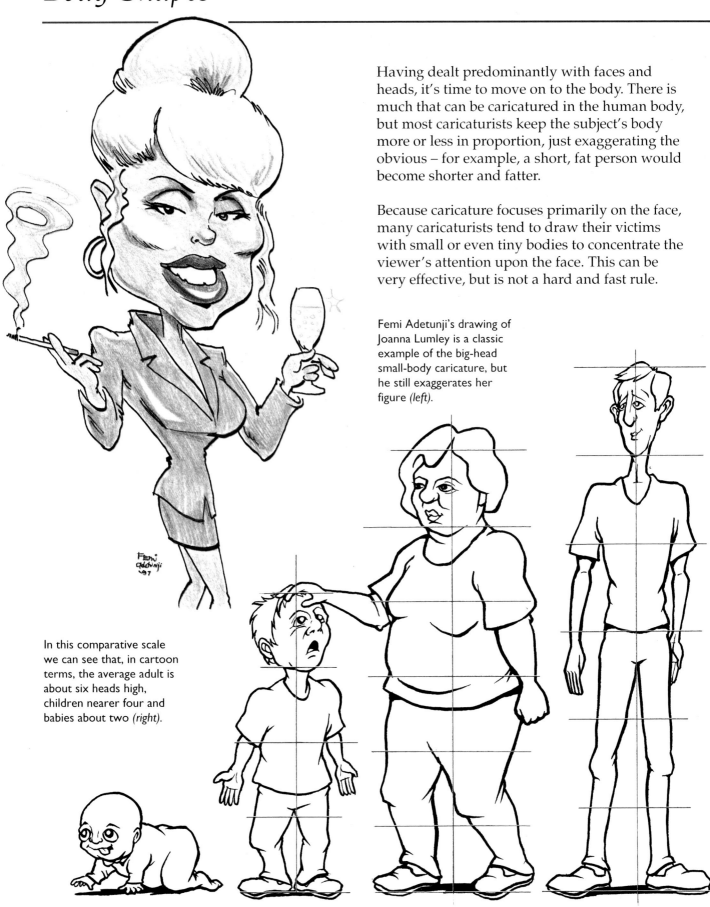

Having dealt predominantly with faces and heads, it's time to move on to the body. There is much that can be caricatured in the human body, but most caricaturists keep the subject's body more or less in proportion, just exaggerating the obvious – for example, a short, fat person would become shorter and fatter.

Because caricature focuses primarily on the face, many caricaturists tend to draw their victims with small or even tiny bodies to concentrate the viewer's attention upon the face. This can be very effective, but is not a hard and fast rule.

Femi Adetunji's drawing of Joanna Lumley is a classic example of the big-head small-body caricature, but he still exaggerates her figure (left).

In this comparative scale we can see that, in cartoon terms, the average adult is about six heads high, children nearer four and babies about two (right).

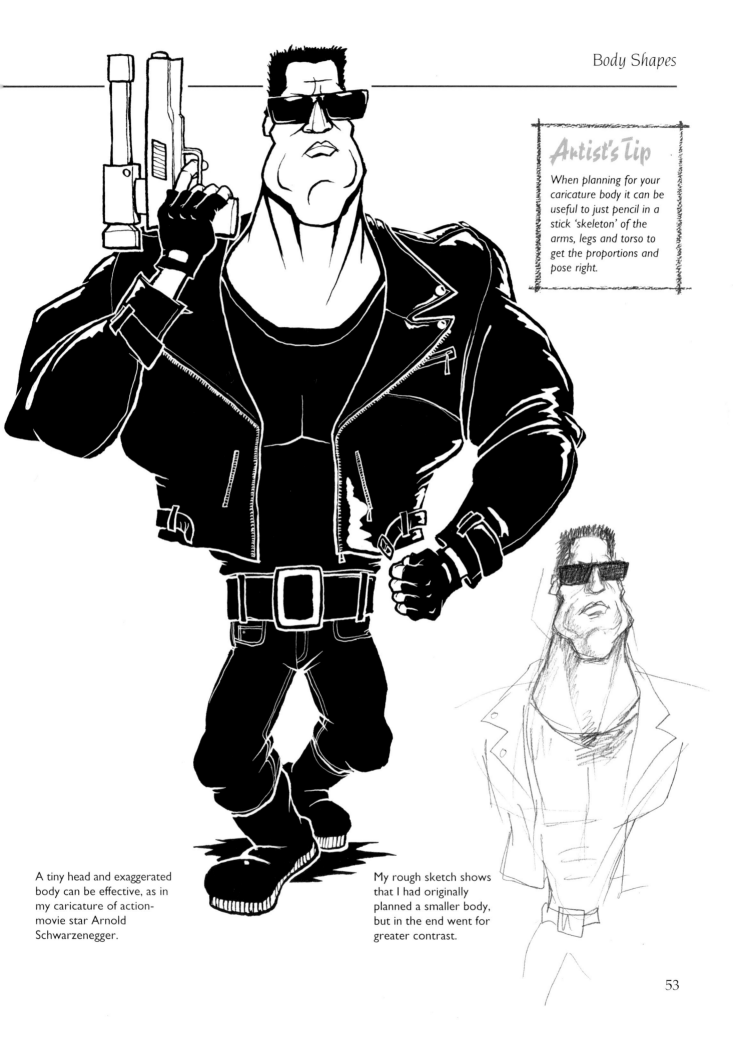

Artist's Tip

When planning for your caricature body it can be useful to just pencil in a stick 'skeleton' of the arms, legs and torso to get the proportions and pose right.

A tiny head and exaggerated body can be effective, as in my caricature of action-movie star Arnold Schwarzenegger.

My rough sketch shows that I had originally planned a smaller body, but in the end went for greater contrast.

Posture and Gesture

As the face has expressions, so the body has posture. You can similarly read a lot from the body language of the way someone stands or sits. From the caricaturist's point of view there are two main sorts of posture: observational and character. Observational postures are obtained by watching how your subjects move and hold themselves, whether they slouch or stand bolt upright.

With a character pose, on the other hand, you may be trying to imply something through the subject's posture – for example, someone known for their intellectual prowess may be pictured in

the pose of Rodin's *The Thinker*, sitting deep in contemplation. Again, this is caricature, so don't be afraid to exaggerate the poses.

It is possible to convey a lot of meaning with just a gesture, but don't forget one gesture or hand signal may seem harmless to you but may imply something entirely different to someone else.

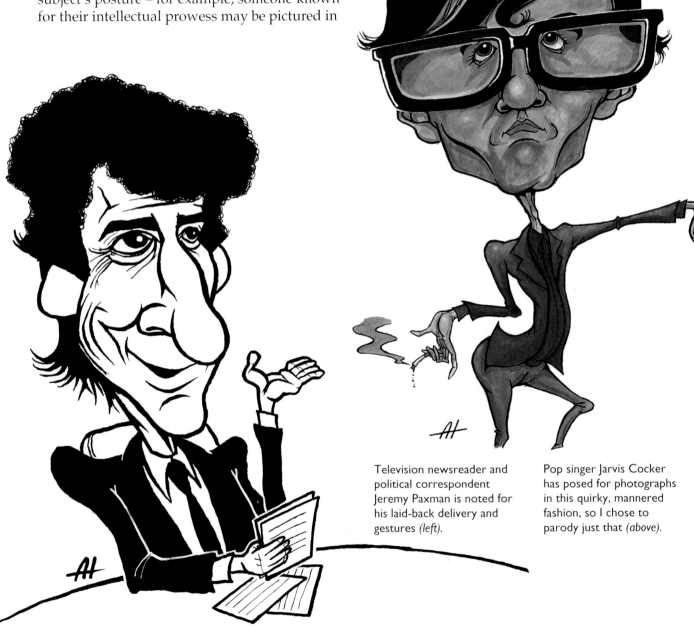

Television newsreader and political correspondent Jeremy Paxman is noted for his laid-back delivery and gestures *(left)*.

Pop singer Jarvis Cocker has posed for photographs in this quirky, mannered fashion, so I chose to parody just that *(above)*.

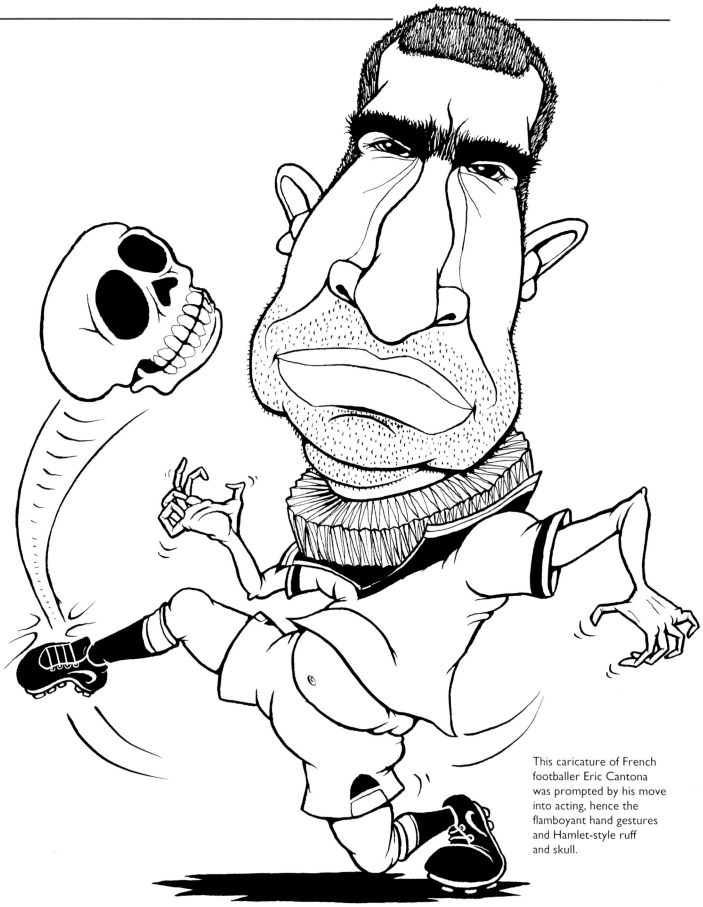

This caricature of French footballer Eric Cantona was prompted by his move into acting, hence the flamboyant hand gestures and Hamlet-style ruff and skull.

Clothes and Costume

They say clothes maketh the man (or woman), and this is even more true for caricature. Unless you draw all your caricatures naked (and you might), you will need to consider how to clothe them appropriately.

There are basically two types of clothes: the ordinary, everyday clothes people may wear, and costumes you choose to imply comment with. For instance, someone prone to making very public mistakes could be drawn in the outfit of a medieval court jester or fool.

Pay particular attention to detail in military uniforms or showy stage costumes as these are usually designed in a particular way for a reason. It is worth doing a little research to get this sort of information right, but don't forget you can still exaggerate those details – such as adding a ridiculous number of medals to a high-ranking military officer.

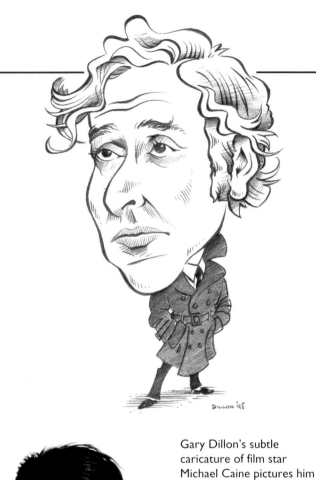

DILLON '98

Gary Dillon's subtle caricature of film star Michael Caine pictures him in his spy movie days, overcoat and all *(above)*.

This caricature of the older Las Vegas Elvis Presley by Jonathon Cusick gets his jump suit spot on. Note the cheeseburger designs *(below)*.

This lady represents a sales company that covers Russia, so I chose to draw her in a full Cossack dancer's costume *(left)*.

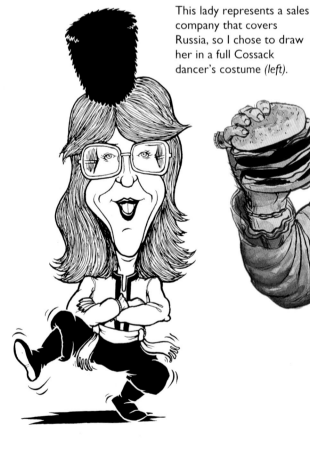

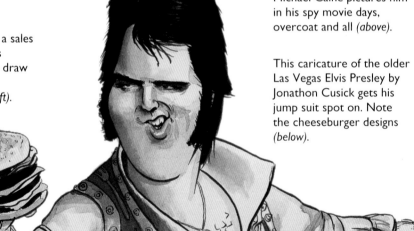

56

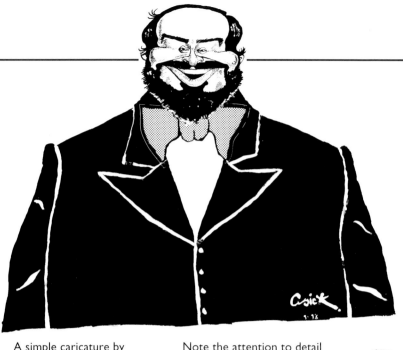

A simple caricature by Jonathon Cusick makes use of Luciano Pavarotti's exaggerated suits and bow ties (above).

Note the attention to detail in the uniform and headscarf in this caricature of Yasser Arafat by John Leer (below left).

This supergirl-style costume is largely made up from ideas I have seen in American comics (above).

Femi Adentuji's caricature of boxer Chris Eubank draws attention to his pretensions to be lord of the manor (below).

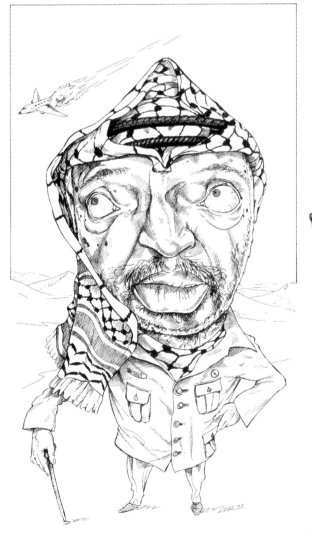

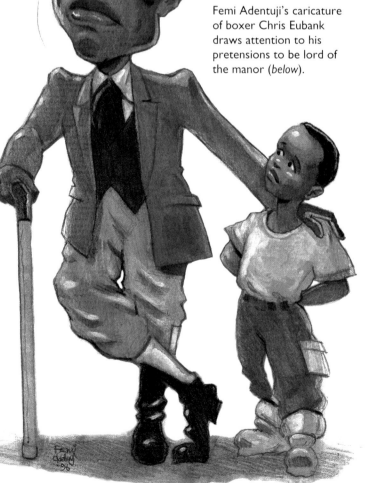

Symbols and Props

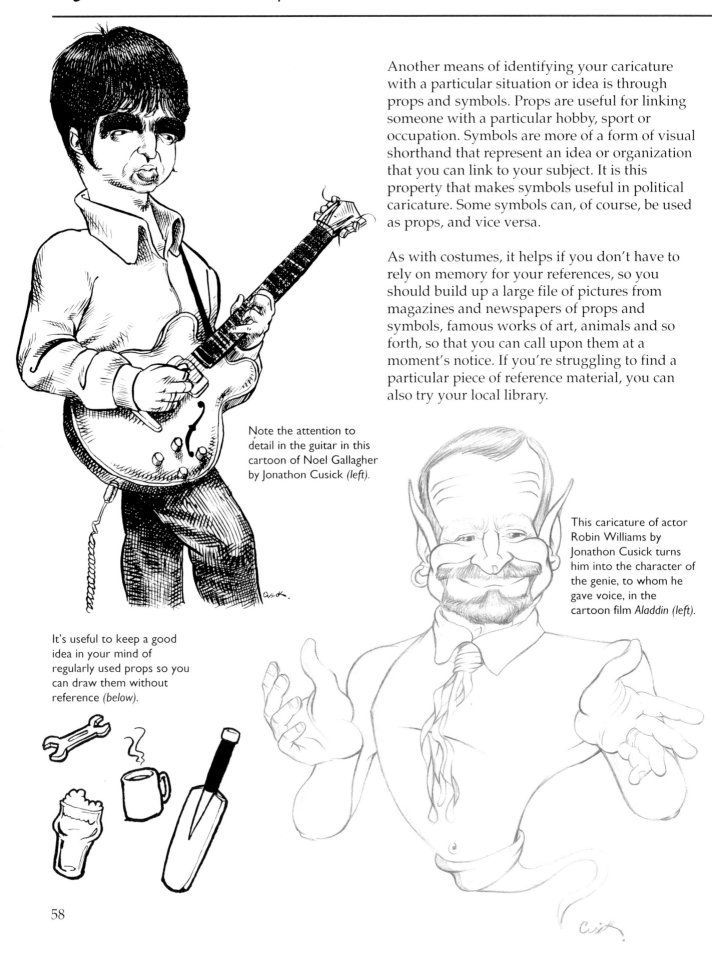

Another means of identifying your caricature with a particular situation or idea is through props and symbols. Props are useful for linking someone with a particular hobby, sport or occupation. Symbols are more of a form of visual shorthand that represent an idea or organization that you can link to your subject. It is this property that makes symbols useful in political caricature. Some symbols can, of course, be used as props, and vice versa.

As with costumes, it helps if you don't have to rely on memory for your references, so you should build up a large file of pictures from magazines and newspapers of props and symbols, famous works of art, animals and so forth, so that you can call upon them at a moment's notice. If you're struggling to find a particular piece of reference material, you can also try your local library.

Note the attention to detail in the guitar in this cartoon of Noel Gallagher by Jonathon Cusick *(left)*.

This caricature of actor Robin Williams by Jonathon Cusick turns him into the character of the genie, to whom he gave voice, in the cartoon film *Aladdin (left)*.

It's useful to keep a good idea in your mind of regularly used props so you can draw them without reference *(below)*.

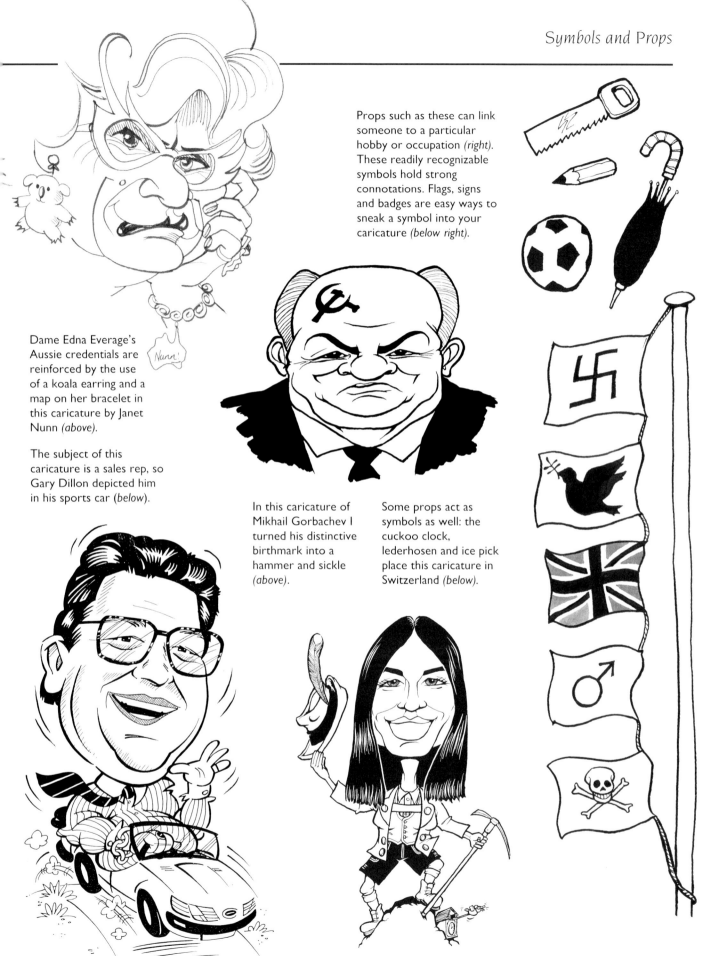

Props such as these can link someone to a particular hobby or occupation *(right)*. These readily recognizable symbols hold strong connotations. Flags, signs and badges are easy ways to sneak a symbol into your caricature *(below right)*.

Dame Edna Everage's Aussie credentials are reinforced by the use of a koala earring and a map on her bracelet in this caricature by Janet Nunn *(above)*.

The subject of this caricature is a sales rep, so Gary Dillon depicted him in his sports car *(below)*.

In this caricature of Mikhail Gorbachev I turned his distinctive birthmark into a hammer and sickle *(above)*.

Some props act as symbols as well: the cuckoo clock, lederhosen and ice pick place this caricature in Switzerland *(below)*.

People As Objects

One useful trick you have in your armament is to draw your caricature as an animal. There are several reasons why you might do this. Some animals hold symbolic significance, for instance the bear often represents Russia and the owl represents wisdom. Your subject may own a pet, or they may merely resemble a particular animal – for example, someone with a beaky nose could be drawn as a bird of some description. It is even possible to draw your subject as an inanimate object.

The hard part can be identifying the features on your caricature with features on the object you intend to draw them as. This can be easy with animals, however, as they have corresponding eyes, noses, mouths or beaks. Nevertheless, you will almost certainly have to make a few compromises, either with your caricature or the thing you're turning it into.

You can incorporate maps in a caricature, as this depiction of Mahatma Ghandi as India demonstrates (right).

You don't have to distort the face to fit the animal, as Janet Nunn's caricature of the Duke and Duchess of Windsor shows (below).

John Major enjoyed cricket, so it seemed only natural to draw him as a (lame) duck (below).

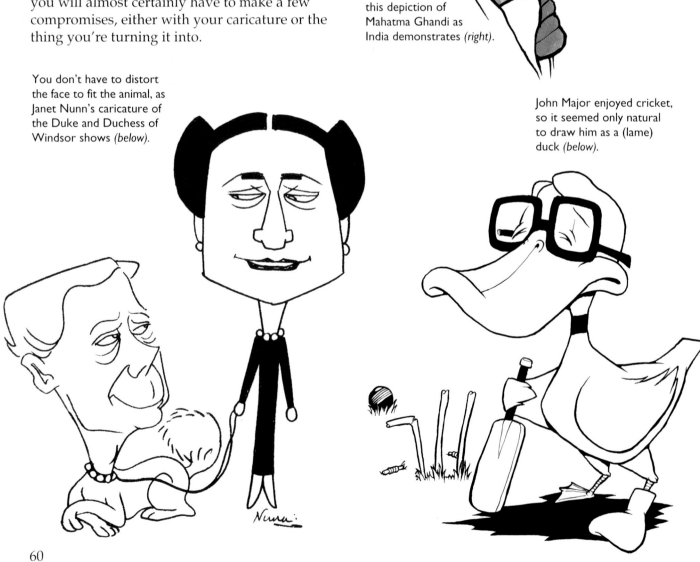

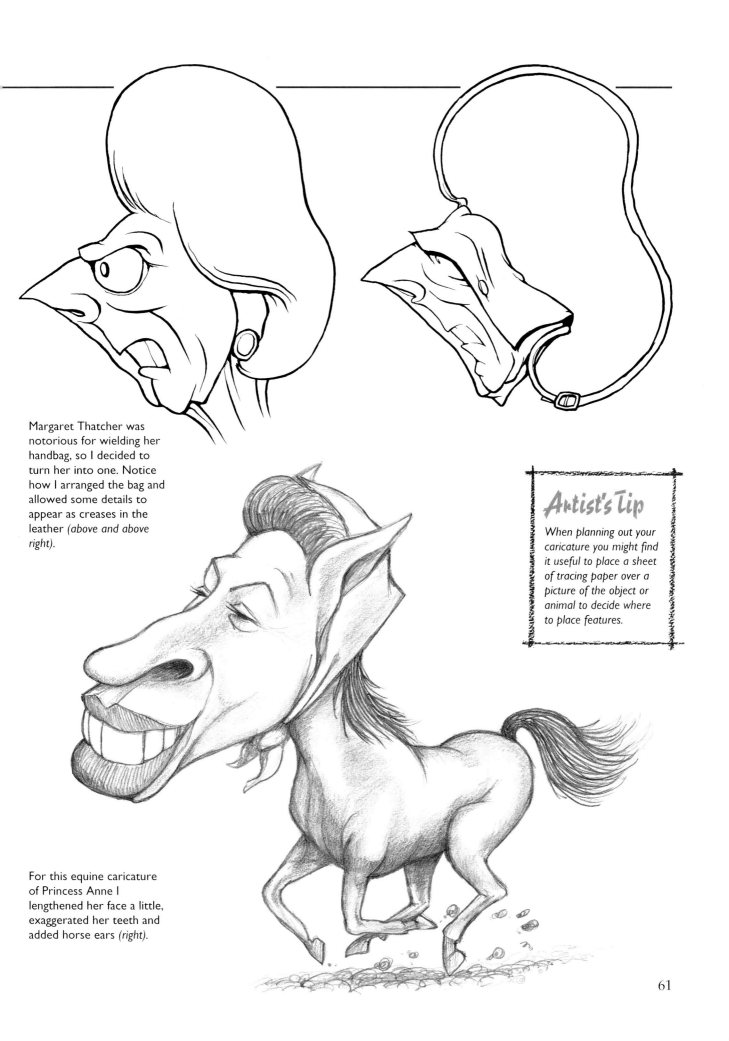

Margaret Thatcher was notorious for wielding her handbag, so I decided to turn her into one. Notice how I arranged the bag and allowed some details to appear as creases in the leather (*above and above right*).

For this equine caricature of Princess Anne I lengthened her face a little, exaggerated her teeth and added horse ears (*right*).

Caricatures in Setting

The setting of your caricature can sometimes be all-important, especially if you are drawing a political caricature. Backgrounds or scenery can place the caricature in a particular place or time, or you can locate your caricature in all manner of situations, real or imaginary, to make a point or comment.

If you're going to include other people in the caricature, try to keep them in proportion. Also, if these people are 'imaginary', make them look in keeping with the style of the caricature, rather than just using cartoon-style figures. One way of finding models for this purpose is to use caricatures of friends and family, or even of yourself, to 'fill out' crowd scenes.

You can add text to your caricature using speech bubbles, captions or even signs and labels. While I prefer wordless caricatures, sometimes text is unavoidable to get the message across.

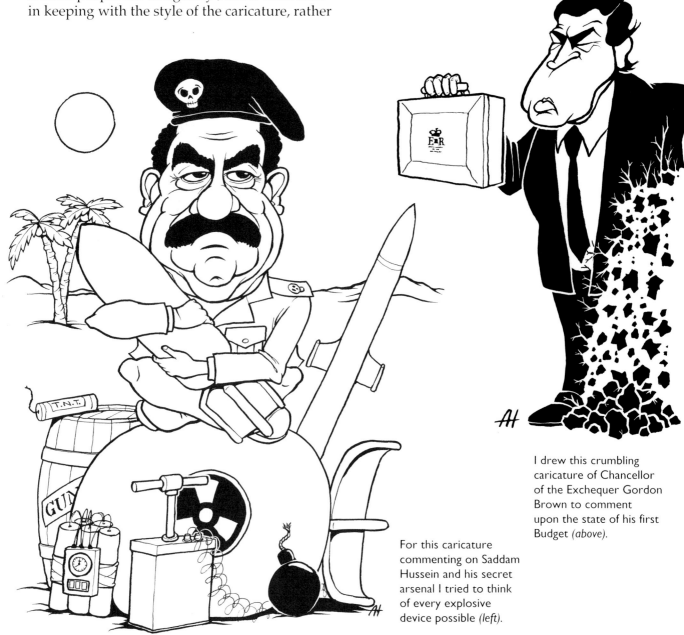

I drew this crumbling caricature of Chancellor of the Exchequer Gordon Brown to comment upon the state of his first Budget (above).

For this caricature commenting on Saddam Hussein and his secret arsenal I tried to think of every explosive device possible (left).

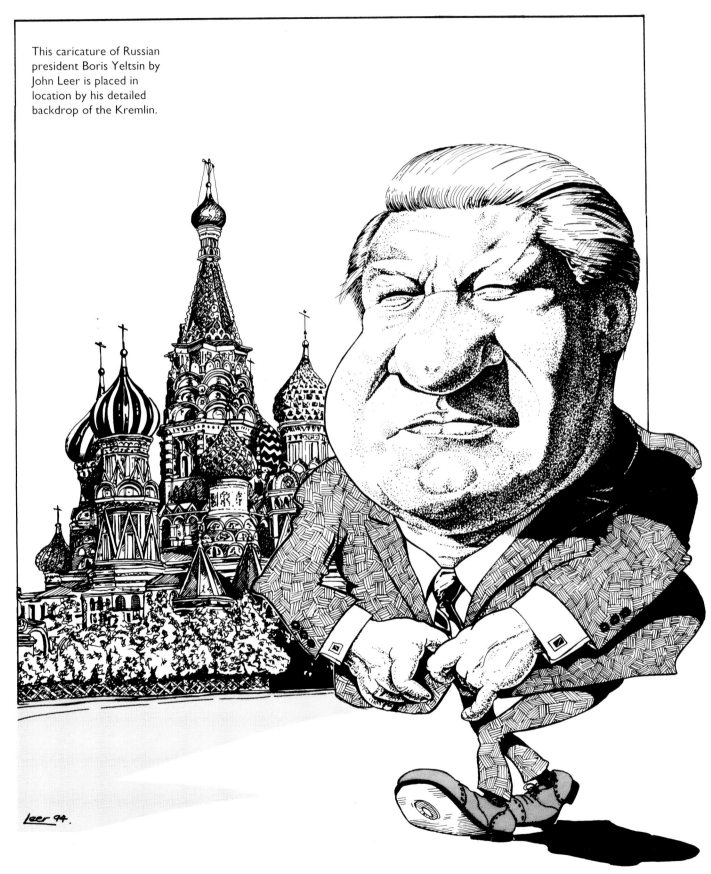

This caricature of Russian president Boris Yeltsin by John Leer is placed in location by his detailed backdrop of the Kremlin.